Public Planet Books

A Series Edited by Dilip Gaonkar, Jane Kramer, and Michael Warner

Public Planet Books is a series designed by writers in and outside the academy—writers working on what could be called narratives of public culture—to explore questions that urgently concern us all. It is an attempt to open the scholarly discourse on contemporary public culture, both local and international, and to illuminate that discourse with the kinds of narrative that will challenge sophisticated readers, make them think, and especially make them question. It is, most importantly, an experiment in strategies of discourse, combining reportage and critical reflection on unfolding issues and events—one, we hope, that will provide a running narrative of our societies at this particular *fin de siècle.*

Public Planet Books is part of the Public Works publication project of the Center for Transcultural Studies, which also includes the journal *Public Culture* and the Public Worlds book series.

Whose Art

Is It?

———————

public planet books

Whose Art Is It?

Jane Kramer

Introduction by Catharine R. Stimpson

DUKE UNIVERSITY PRESS *Durham and London 1994*

© 1994 Duke University Press

All rights reserved

Printed in the United States of

America on acid-free paper ∞

"Whose Art Is It?" © 1992

by Jane Kramer originally

appeared in *The New Yorker*

21 December 1992.

Typeset in Bodoni Book

by Tseng Information Systems

Library of Congress Cataloging-

in-Publication Data appear on

the last printed page of this book.

Second printing, 1995

Contents

Whose Art

Is It?

———

Introduction

*by Catharine
R. Stimpson*

T he great journalistic essay has the vividness of pho-
tography, the suspense of the detective story, the
pitch of history, the nuances of psychology, and
the honed energies of literature. *Whose Art Is It?*
by Jane Kramer is such an essay, the most compelling
and intelligent of narratives about cultural turbulences
in the United States in the late twentieth century. One
of Kramer's virtues is habitual curiosity, her capacity for
bold and subtle questions. *Whose Art Is It?* asks many
questions, but it returns again and again to two that have
roiled and rolled contemporary public discourse. What
is multiculturalism? And what is political correctness—
the mean, whiny cop on the beat of multiculturalism?

Kramer is writing about the South Bronx in the late
1980s and early 1990s. This is an impoverished part of
New York City, but New York City, despite its idiosyncra-
cies, has not left planet Earth for Krypton. The dramas
of the South Bronx are American, and even global, dra-
mas. Kramer is tough and tenderminded, aware of the

proximity of irony and poignancy, and scrupulously fair. Her story about multiculturalism and political correctness only too vividly illustrates Emerson's maxim, "One man's justice is another's injustice; one man's beauty, another's ugliness; one man's wisdom, another's folly; as one beholds the same objects from a higher point." (Emerson 1990, 172)

A word that roils and rolls public discourse necessarily embodies different, often contradictory, meanings, values, and sentiments. For cultural disturbances arise when individuals and institutions are fighting over which meanings, values, and sentiments ought to prevail in a society. "Multiculturalism" does have a neutral historical and anthropological meaning: groups with diverse cultures—that is, patterns of behavior and belief—have coexisted on earth in the past and do coexist in the present. The nature of this coexistence varies along several spectra. Cultures can be ignorant of each other, indifferent to each other, or actively encounter each other. These encounters can be bloody, tense, or tranquil; destructive or creative or both. A second, more focused, but still neutral, meaning is that groups with diverse racial and ethnic identities have coexisted and do coexist on earth. This coexistence, too, varies along several spectra. A third, far narrower, meaning is the efforts of four racial groups in the United States to gain equality: African Americans, Hispanic Americans, Asian Americans, and Native Americans. The struggles

of these groups to gain equality—for example, through affirmative action—show how bloody and tense American multiculturalism has been.

By 1992, when Kramer wrote *Whose Art Is It?*, the word multiculturalism was losing its neutrality. Complicating this process were additions to the already messily large number of meanings attached to the word "culture" itself. One controversial expansion took place simultaneously in politics and education. More and more groups were calling themselves cultures with shared norms and values, feelings of community, and a claim to public recognition and/or support. The more groups that appeared, the more "multi" multiculturalism became. The rainbow emanated a far wider spectrum of colors. In the United States, groups with a common race, ethnicity, religion, or class had long proclaimed their place in the public sun. New York had seen parades in honor of Italian Americans on Columbus Day, Irish Americans on St. Patrick's Day, working men and women on Labor Day. Now, a new group took gender as the source of a viable public identity; another the condition of being physically handicapped; still another, the most controversial, sexual identity. This expansion bred difficulties. One was deciding when an axis of group identity was significant. I like my role as founding member of my block association on Lower Westervelt Avenue in Staten Island. We do good civic work. We are not, however, a major tessera in New York City's gorgeous mosaic. A second difficulty was de-

3

ciding when an axis of group identity was tolerable. I, for example, fear and despise skinheads. No doubt no skinhead worth his haircut would like me. Still a third difficulty was the fact that a person might simultaneously belong to several cultures that were grimly at odds with each other. Think of the situation of a gay white man born into a working-class Catholic family that considers the reforms of Pope John XXIII, let alone Queer Nation, as the devil's doing. This gay man still loves his family, goes home for Christmas, and permits them to pray for the demons to leave his body. He also practices law, lives in a gentrified section of a large city, and plans to marry his African American male partner in a ceremony in an ecumenical church with "out" gays and lesbians in the congregation.

At the same time, at least four positions about multiculturalism—volatile sets of meanings, values, and sentiments—were competing for dominance. The first was largely the work of staunch political and social conservatives. For them, multiculturalism is decadent and self-destructive, garbage, a "landfill." If the United States is to survive as a world power, position one argues, it must have one culture—in the sense of one set of norms. Citizens must share one morality and identity, firmly based in Western history. Moreover, these conservatives warn fiercely, radical elements in the United States are corrupting culture—in the sense of aesthetic achievement and standards. Radicals from the 1960s

spit on impeccable shared traditions of aesthetic excellence, also based in Western history. The second position is nearer to the political and social center. Position two proposes that the United States is a functioning multicultural nation in an often dysfunctional multicultural world. The history of slavery in the United States might show multiculturalism gone wrong, but the history of successful immigration shows multiculturalism gone right. Position two fears, however, that the United States is jettisoning such overarching values as tolerance that have lessened the bad multiculturalism while strengthening the good. In brief, the United States is perilously close to becoming "Balkanized." The third position, although it has internal differences, is generally less fearful of Balkanization. Position three submits that the United States has insufficiently recognized and prized its multiculturalism. If it were to do so, our values, arts, and media would be richer and better. Academic curricula, for example, would be more accurate if they were more "inclusive" of the experiences of minorities and marginalized groups. The fourth position, which proponents of Afrocentrism state most forcefully, calls multiculturalism a sham, a trick, a way of dissolving the centrality of race in a newly-scrubbed American melting pot.

The debate about multiculturalism in America joined the debate about political correctness in the mid-1980s. Now centuries old, the term PC has had more lives than the Saturday morning cartoon creature Wile E. Coyote.

Its metamorphic vitality shows the malleability, shiftiness, and instability of public discourse. In 1793, "political correctness" appears in a United States Supreme Court opinion. The "politically correct" toast, Justice James Wilson wrote, was the "People of the United States," not simply "The United States" (Wexler 1993). The term then dropped into the sludge of lost language to re-appear in the twentieth century as a term of praise among Marxists. This meaning underwent a sea change after World War II, becoming a term of self-criticism among Marxists. A PCer stuck like Crazy Glue to the party line. Then, in the 1980s, PC broadened into campus slang. The PCer accepted all or part of a set of beliefs—in the environment, feminism, the rights of minorities, and a multicultural academy. So defined, I am PC. Moreover, the PCer also had an attitude. He or she was prissy, demanding, self-righteous, thin-skinned, incapable of self-examination, intolerant of disagreement—in brief, without generosity of soul or love of the First Amendment. So defined, I hope not to be PC. Simultaneously, as PC was entering the campus lexicography, it was also installing itself far more pervasively as the household abbreviation for personal computer. The same alphabetical dyad stood for both the politically and culturally suspect on campuses and the economically, technologically, and culturally swell on campus and off.

The undergraduate mockery of PC airs grew, to be codified in the Jeff Shesol cartoon character, Politically

Correct Person. Then, hard-line ideological conserva-
tives picked up the term. For some, like Dinesh D'Souza,
author of *Illiberal Education* (1991), PC-bashing turned
up trumps as a lucrative career move. The conservative
disagreement with certain PC beliefs was longstanding.
PC became a new bit of shorthand with which to dis-
miss and deride such developments as affirmative action,
women's studies, African American studies, or ethnic
studies.[1] PC-bashing also reiterated the obnoxious charge
that installing PC beliefs in the academy led inexorably
to the loss of academic quality, values, and merit. In
brief, change entailed the overthrow of reason. PCers, de-
clared the polemical advocates of positions one and two,
were ham-handed advocates of multiculturalism. And
multiculturalism was barbarism's latest, scowling face,
a barbarism that rubbished and reduced everything to
politics and power.

The conservative pickup of PC bred two siblings, the
first more coherent than the second. First, some liberals
joined the conservative reaction against PC, especially
if they believed that PC was imposing a new orthodoxy
on the American campus and disdaining free speech
and the sanctity of the First Amendment. Second, both
conservatives and liberals turned on deconstruction, an
important method of interpreting literature and language
with roots in modern European philosophy.[2] This turn
elided all PC beliefs with deconstruction, linguistic in-
determinacy, and radical postmodernity, and thus, in a

power surge that short-circuited reality, with rabid and thoughtless relativism. The difficult career of Paul De-Man was then turned into the exemplary case of the alliance among PC, deconstruction, and the destruction of Western values. DeMan was a European who arrived in the United States after World War II. During his scholarly career, he became an influential and much-admired professor of literature and the primary American advocate of deconstruction. In 1987, to the surprise and dismay of DeMan's admirers, a researcher discovered that De-Man, during World War II, had published anti-Semitic articles.

Then, the media discovered PC and broadcast largely conservative rhetoric. What had been an often stupid and malicious argument about higher education became a media feeding frenzy, especially for a generation of middle-aged reporters and editors with fond memories of their undergraduate years. The breakthrough publication was the December 24, 1990, issue of *Newsweek*. Its lurid cover proclaimed the presence of "Thought Police On Campus." The media saw PC everywhere. In March 1992, a reporter traced the spread of the term "PC" through the media. Sampling twelve major newspapers, she found PC used 180 times in 1989, 323 times in 1990, and 2,091 in 1991 (Siegal 1992). PC began to resemble UFOs, unidentified flying objects. People just know UFOs are there, even though the evidence behind their claims is limp, skimp, cranky, hallucinatory, and paltry. Fat-

headedness began to sizzle merrily in the fire of publicity. Books and articles, TV and radio shows shouted about a group of democracy-hating radicals who were turning the American campus into a Communist re-education camp, an ayatollah's paradise, the site of Senator Joseph McCarthy's reincarnation, and Nazi Germany. As the fires of publicity burnt out of control, PC began to rival totalitarian states and religious fundamentalism as the great threat to human liberty. PC also became a common term nationally. For example, in November 4, 1991, *People* magazine reviewed *Scarlett*, the sequel to *Gone with the Wind*. "The new, politically correct Scarlett," *People* grumped, "tends to a dying Mammy" (40). Because the United States media belong to and control global communications systems, the PC-bashing went international as well. Multinational corporations spread the bad word about PC and multiculturalism. I got calls from print journalists in Canada and radio journalists in Australia, all shuffling the same tiny pack of anecdotes to prove that PC had conquered the American campus.

Responding to PC as a cultural theme, Republicans made it a campaign theme as the Grand Old Party prepared to duke it out with its opponents in the 1992 and 1994 elections. Republicans hustled an argument about culture and politics into the meat grinder of party politics. In a May 1991 commencement speech at the University of Michigan—the site of an early, bad speech code—President George Bush diagnosed PC as a cam-

pus sickness that Republicans could cure. PCers, he claimed, promised to heal the ancient disease of prejudice but really carried the virus of a new intolerance. Next, Lynne V. Cheney, then Chair of the National Endowment for the Humanities, began to use her position as national steward of the humanities as a bully pulpit for this theme. For example, in a September 1991 speech to the National Press Club, she warned that "Political correctness typically involves faculty members trying to impose their views on others." In a Fall 1992 report, *Telling the Truth*, paid for with taxpayers' money, she warned of an American academy drifting towards the status of Indoctrination Central (Cheney 1992). Republican PC-bashing mixed its attacks on the academy with attacks on the "cultural elite" or, to abbreviate, CE. Both PCers and CEers were liberals if not radicals; Democrats if not leftists.

Though old, the saw "Live by the sword, die by the sword" has a sharp edge. As the Republicans inflated and then attacked PC for partisan gain, recycling a handful of anecdotes about PC horrors, they helped to spawn a conventional "PC of the right." In 1991, *Newsweek* wrote of two opposing camps of "PCness" on and off the campus. One "stresses legally enforced 'fairness' and tolerance in race, gender and sexual orientation." The other, to which Bush appealed, "worships individual rights and 'traditional' religion and family roles" (October 28, 1991). Finally, towards the end of 1992, with Bill

Clinton's presidential victory, PC became a less potent political weapon and a cooler topic for the media. When *Whose Art Is It?* was first published, a month after Clinton's November victory, PC had settled down to a weird triple identity. First, it had become an academic subject, the focus of anthologies, symposia, and sessions at the meetings of disciplinary organizations. Second, it had become part of vernacular English, slang for the irritating attempt, usually by one minority or another, to impose rigid, self-serving codes of thought, speech, and conduct. Third, and most important, the unresolved issues that the PC debate represented—such as the nature of the academic curriculum, race relations, gender relations, the nature of freedom of speech, and the fate of American liberalism—retained their power to torment the nervous system of the American body politic.

11

Why the PC phenomenon took off as it did—on United States campuses, then in national and international culture—is an absorbing question. Explanations pile up so thickly that the PC phenomenon seems strenuously overdetermined. One obvious reason is that the advocates of multiculturalism made moral, intellectual, and political mistakes, unpalatable though this advocate of multiculturalism finds such an admission. Obviously, a hyperbolic, manipulative PC-bashing has happened. It was, for example, an offensive canard to call the American campus an island of repression in a sea of freedom. Nevertheless, some PC is there, a stickleback fish swim-

ming in educational and cultural waters. On some campuses, anti-Semitism has not been attacked as sharply as other forms of racism. Virulently anti-white statements are sometimes ignored more than virulently anti-black statements. Zealots, knaves, and fools have occasionally dominated academic programs. To be sure, some of these errors were meant to be well-meaning solutions to bad problems. Educators did not draft speech codes as an empty exercise in a composition class. They were trying to deal with painful, lousy speech—a student radio commentator making racist jokes or an anonymous lout scrawling, "A mind is a terrible thing to waste on a nigger," on a wall. Some codes were, alas, unconstitutional.

Two particular dangers are woven into the borders of the fabric of the new interdisciplinary fields, such as African American studies or women's studies, for which multiculturalism now serves as a blanket rubric— a blanket rubric at once smothering and secure. First, these new fields must argue again and again that their subject matter is legitimate. The need for constant self-justification and self-explanation gets frustrating. Frustration breeds impatience and some paranoia. No mathematician must waste energy telling a trustee, dean, or colleague that mathematics has mattered in the past, does matter in the present, and will matter in the future. Frequently expressed in suspicious and hostile rhetoric, the belief that these new academic fields are ille-

gitimate flows from deep cultural convictions that their subject matter is secondary, trivial, or deviant. If, no matter how unconsciously, you devalue African Americans, you will devalue African American studies. If you hate homosexuality, you will scorn gay, lesbian, and bisexual studies. Second, the subject matter of each of the new interdisciplinary fields is a sociocultural group with a primary source of identity: race for African American studies or Asian American studies; a racially-charged ethnicity for Latina/Latino studies; gender for women's studies; sexual preference for gay and lesbian studies.[3] These groups vary amongst themselves, but they share certain characteristics. Their primary source of identity is at once biological and cultural, a blending of nature and nurture that has varied throughout history. Next, this primary source of identity has historically been hated, feared, and despised. The groups—as groups—have lacked political, economic, and cultural clout. Their histories have been drastic, grinding, grievous, difficult. They have been named rather than self-naming, spoken for rather than speaking. As *Whose Art Is It?* discusses, powerless people have their reasons for attacking representations of themselves that their group did not generate. If being symbolized can seem a symbol of powerlessness, then attacking a symbol can seem a counter-assertion of some power. Establishing an academic field is, in part, a systematic, formalized act of self-naming. Unfortunately, using a group identity to

13

structure an academic field can risk reductionism. Its practitioners may press the complexities of human identity down to one source; may erase differences within the group; may act as if the suffering of the group is all that matters. Academic life is to document suffering, blame those who are responsible for the suffering, celebrate the survivors of suffering, and advocate the end of suffering and the triumph of the survivors.[4]

Yet even these errors and dangers cannot account for the extent of the PC phenomenon and the rapidity with which it grew. Another explanation is that the United States, like every other country, is living through a period of global economic, social, and cultural changes that together accelerate cultural encounters and collisions. The Other is there—on CNN, at the border, in the classroom. The presence of the Other can be disquieting. Demographically, the United States itself is far more diverse. Think, for example, of the growth of Asian American and Hispanic/Latino/Latina populations. These developments provide the world with more texts (in arts, letters, popular culture, education, and fashion) and with more readings of texts, old and new. The mints of cultural currency are pouring forth new notes. The figure of Caliban in Shakespeare's *The Tempest* takes on new meaning when artists, writers, and critics see him as the indigenous figure whom Europe, in the person of Prospero, has colonized. These changes in culture might be tricky enough to absorb on their own. Unfortunately, they

are happening during an economically unstable period as well. The supply of material resources has not kept up with the luxurious profusion of cultural texts and readings. Various groups, many with grievous histories, must compete for resources such as scholarships or jobs. If a young white man feels—no matter how prejudicially—that a young black man or a white woman has snatched something of value away from him, the young white man is not going to be in a mood to read Alice Walker. His applause preference is going to be Rush Limbaugh's attacks on PC and feminazis.

Obviously, too, the intellectually implausible but politically shrewd linking of PC with deconstruction fed at least two anxieties deep enough to claim the status of passions. One is about rhetoric: the fear that language is indeed unreliable; that even the plainest of speech issues from a treacherous larynx. The anti-PCers promised their audience that good people could say what they mean, mean what they say, and walk securely in the Naturalizer shoes of language. The second anxiety is about history: the fear that any change is unreliable, a matrix of violence, loss, and decay. More concretely, adding the study of the Harlem Renaissance to the study of the Renaissance seems tantamount to scrawling graffiti on a Michelangelo statue or, even worse, smashing the marble with a sledgehammer. That anyone might find plausible the implausibility of rendering PC a synonym of deconstruction signifies the stickiness of the

political position in which advocates of PC causes found themselves. Because they were supporting changes that provoked social anxiety, they could not simply argue rationally for change. Their rhetoric also had to make people feel better about change. Unfortunately, many of the supporters of change were academics who found themselves in a double bind. On the one hand, they were unschooled in public debate, uninitiated in the cut-and-thrust of postmodern media politics. Too often, their notion of a sound bite is a paragraph. On the other hand, anti-PCers, drawing on the traditional anti-intellectualism in American life, could dismiss PC simply by its guilt-by-association with those off-the-wall radical professors.[5]

Christopher Newfield, a scholar and critic, suggests at least three more sources of the PC phenomenon. First, PC-bashers were able to exploit certain directions and tensions within the contemporary humanities. For some contemporary humanists do offer radical critiques of culture and society. ". . . fields like Chicano studies and queer theory become increasingly unsafe when they move from offering more pieces of the cultural mosaic to criticizing that mosaic's basic design" (Newfield 1993, 309). Moreover, the contemporary humanities were off-balance in their response to attacks because they were suffering an identity crisis about their purpose. Are they to study literary history or explore cultural problems? Second, conservatives needed to find another demon to

replace Communism in the collective psychology and politics of the United States. PC, with its etymological roots in Marxism, was worth trying as a substitute devil.[6] To this, I would add dully: As people perceive how very heterogeneous the world is, their response is to intensify a need for a master narrative, whether this need is consciously or unconsciously felt. The more there is to see, the more we call for a structure or story with which to organize and explain it. What distinguishes us is not whether we need a master narrative, but how we respond to this need. Do we scrupulously analyze it? Or, do we construct a narrative that prizes democratic pluralism? Or, do we construct a narrative that justifies supremacy and solidarity for some and ethnic cleansing for the rest?

Third, Newfield argues, PC-bashing appealed to contemporary racial fears. Good Americans can no longer express them through crude prejudice and stereotyping. Racial fears, however, have not gone away. Among them is the suspicion that racial differences can lead to anarchy. To cope, good Americans seek to obliterate racial differences, no matter how salubrious they might be, by dedicating themselves politically to racial integration and culturally to a "common culture." The success of a Dinesh D'Souza, Newfield writes, only makes sense as an "overriding effort to identify civil rights with civil war. More precisely, it links revolution to any notion of civil rights based on a consciousness of racial subordination and difference" (320).[7] Similarly, I add, the

success of a Dinesh D'Souza makes sense as an effort to link the emancipatory exploration of sex and gender, which feminists do, with civil and cultural chaos, which conservatives have said feminists brew.

Navigating these currents of change and tides of history, *Whose Art Is It?* is far too original to investigate political correctness and multiculturalism by conducting yet another tour of the American campus. Instead, Kramer goes to the South Bronx, a place of suffering, poverty, crime, drugs, unemployment, and AIDS. Here, there are no resources to waste; here, powerlessness may not give birth to a terrible beauty but only to terror; here, survival itself is a form of genius. The mystery that Kramer wants to solve is why, in 1992, John Ahearn, a famous artist, would take down a group of sculptures five days after he had installed them with great effort in the South Bronx.

Ahearn is white, the well-educated son of a Republican doctor in Binghamton, New York. For several years, he had lived and worked, not in the fashionable neighborhoods of Soho or Tribeca in Manhattan, but on Walton Avenue in the South Bronx—one of three whites to do so. Catholic, capable of moral and artistic enthusiasms, he impressed several friends as a man who might well have been a priest. Though Kramer admires much about Ahearn, she refuses to romanticize him. Subtle and shrewd in her reading of character, she suggests that Ahearn found the South Bronx a necessary setting

for the making of his art. He also collaborated with a second artist in the borough, Rigoberto Torres, who preferred to be called Robert. Because of the South Bronx setting, Kramer's story of an artist and a public outcry against his work is far more heart-rending than stories of other contemporary artistic struggles—that, say, between the defenders of the homoerotic photographs of Robert Mapplethorpe and the avatar of conservatism, Senator Jesse Helms, that erupted in 1989. For neither camp was sheer survival an issue. The Mapplethorpe estate has money and the esteem of the art world. Jesse Helms eats very well in the Senate dining room and has the esteem of his supporters.

On April 1, 1986, the New York City Department of Cultural Affairs began to choose, as part of its public art program, an artist to create a piece in front of a new police station in the 44th Precinct in the South Bronx. Kramer is an acute, ironic observer of the ways and byways of an official bureaucracy when it functions as a patron of the arts. After a complex process, a large panel gave Ahearn the commission. For a number of reasons, he did not include Rigoberto in his plans. Ahearn decided to adapt a high, Western, aesthetic tradition to the South Bronx and create bronze statues done from life casts of three of his immediate neighbors: Raymond, a Hispanic, with Toby, his beloved but deceased pit bull; Daleesha, an African American adolescent, a "street child," on a pair of roller skates; and Corey, a second

African American, with boom box and basketball. None of the three were "sterling" characters, but they were part of the neighborhood and part of the largeness of life. As Kramer writes, "They may be trouble, but they are human, and they are there" (38).

Ahearn next went through a strenuous, multi-year set of negotiations in order to get his plans approved by various agencies, including the local community board. Raymond and Corey liked Ahearn's work. It had real use value for them. Raymond, for example, found the statues a fitting memorial for his dog. In September 1991, after everyone had signed off on the project, and less than a week before the bronzes were to be installed, opposition blew up. Historically, of course, public art has provoked outrage. The artistic and psychological success of the Vietnam Veterans' Memorial wall in Washington, D.C., cannot erase the historical record of the belligerent enmity it once provoked. PC and a fractious multiculturalism inflected the specific controversy over Ahearn's work. The initial source of the difficulty was two black city bureaucrats in the Department of General Services. Without seeing the finished sculptures, in a fit of identity politics, oblivious to the fact that Raymond was not black but Hispanic, the two decreed that only blacks could represent blacks. Ahearn was white and, to boot, a racist. In spite of their efforts, the bronzes were installed. Then, a new opposition, far more appealing than that of the chauvinistic bureaucrats, arose from resi-

dents near the precinct house. Its fountainhead was an
older woman, Mrs. Alcina Salgado, who had raised and
educated four children by working as the head house-
keeper for the family of C. David Schine, Roy Cohn's
sidekick during the McCarthy hearings in the 1950s.
Mrs. Salgado, after retirement, had become a pro bono
community activist. A "small, formidable woman," she
found the bronzes "evil, ugly images" (100). She wanted
more socially stalwart and heroic representations, more
"positive" images that would have use value for her
and her neighbors as they struggled to maintain decent,
self-sustaining lives. Her daughter, educated at Sarah
Lawrence, also argued vigorously against Ahearn. Five
days after installing the bronzes, wanting the neighbor-
hood to be "happy," Ahearn took them down at his own
volition and expense. By the time Kramer published her
essay, there was still no public sculpture in front of the
44th Precinct police station. Ahearn's pedestals stood
without their statues. The social misery, the sheer ordeal
of trying to survive, obdurately remained.

Like the more dangerous career of Salman Rushdie
after the publication of *The Satanic Verses*, Kramer's story
asks adamant questions about culture and politics. The
first, no less vital for being traditional, is about an artist's
obligations. To whom and/or what is the artist respon-
sible? Only to art that is freely conceived and created?
Or is the artist responsible to a community? Is John
Ahearn a "better" artist, morally and aesthetically, be-

cause of his commitment to Walton Avenue? A second, linked question is about the control of art designed for and financed by the public. How much power should the public have in determining what public art is acceptable? And whatever do we mean by "the public?" Who comprises a public? Who are their legitimate representatives? Who speaks for them? Surely a couple of censorious bureaucrats cannot claim veto power over an art project on behalf of an entire race. And surely the art community, encased within its own customs and communal language, cannot decide alone what "the public" should see.

In a pluralistic democracy, such questions cry out for a civic debate to which all citizens have access and in which the debaters have some sense of a shared public life. Sadly and urgently, Kramer shows how far America is from this ideal. One of her most disturbing warnings is how corroded and divided civic life in multicultural America can be. We are fractionating ourselves into smaller and smaller components, splitting the meaning of "public" and "community" more and more finely in a hyperactive social mitosis, multiplying the number of vetoes over any civic project. Hispanics become Puerto Ricans, Dominicans, Mexicans, Ecuadorans, Colombians. "The community" becomes a series of blocks alien to each other. Moreover, if a blockheaded identity politics is at work, members of these groups behave like the vain kings, queens, popes, and burghers before them.

They want art to represent and reveal them only at their nicest, finest, and most flattering. Images are to be "positive." The genre of realism is to redeem the "negative" images of the past and to project the aspirations of the community in the present. If the practitioners of identity politics are out of control in seeking cultural control, their response to a piece of art will also depend upon the identity of the artist. To be acceptable, the artist must belong to the group she or he is representing. As Kramer writes sardonically, ". . . in these treacherously correct days one artist's insensitivity is easily another artist's ironic statement, and it seems to depend less on the artist himself than on what color people think he is" (52).

Kramer sees complexities with piercing clarity. Accepting multiculturalism as a social and demographic fact, she refuses to wax nostalgic for a monolithic sense of "national identity" to which every citizen must submit. She recognizes, however, that Americans cannot pay lip service to multiculturalism while engaging in a "multicultural dialogue [that] is really a lot of strange and disheartening monologues" (44). One feature of these monologues is the belief that an artist must work only with the culture and community into which he or she was born. Such a command-and-control aesthetic destroys multiculturalism through the assertion that "an artist can't accept somebody else's tradition and make it his own, make it something new, make it truly 'multicultural'" (128). Kramer also knows that multiculturalism

has worked better for some groups than for others. Indeed, she has chosen to report on the South Bronx, living proof of this truth. She understands why people in pain want "positive" images—representations of hope, aspiration, and achievement. Yet, she adheres, as I do, to a vision of art's potent rejection of simplicities; its incessant renewals of the marriage of truth, beauty, and apparent impossibilities.

Coincidentally, in 1988, while John Ahearn was in the midst of his frustrating project, Barbara Herrnstein Smith, the literary scholar and theoretician, published a brilliant book about the ways in which groups judge truth and beauty called *Contingencies of Value*. She argues that we do not cling statically to transcendental measures and yardsticks. On the contrary, our evaluations are contingent, a "changing function of multiple variables" (Smith 1988, 11). A packed, magisterial paragraph near the end of her book has great relevance to any consideration of cultural value, cultural values in a multicultural society, and Kramer's story. Human society, Herrnstein Smith proposes, is conflictual and inequitable, although our actual conflicts and inequities change. Because of this, our sense of "the best" will vary. It will depend upon what seems to be "the good" for some people under some circumstances. Because of this, we who care about judging cultures well must regard the conditions under which people make judgments. We must then make the

processes of evaluation as strong as possible. Herrnstein Smith writes, "It seems unlikely that there can be a world altogether free of conflicts of interests or of disparities of resources among individual subjects and different sets, tribes, or communities of subjects: conflicts and disparities that are structural and systemic, the residue of history, the traces of what there is and how it has been, and the product also of what is differently remembered and imagined as *otherwise*. This is *not at all* to say that the poor will always be with us or that any current disparities of resources—those, for example, along sexual or racial lines—are natural or inevitable. It is to say, rather, that 'the best' is always both heterogeneous and variable: that it can never be better than a state of affairs that remained more or less than good *for some people*, or got considerably better for many of them *in some respects*, or became, *for a while*, rather better on the whole. If, as I believe, there can be no total and final eradication of disparity, variance, opposition, and conflict, and also neither perfect knowledge nor pure charity, then the general optimum might well be that set of conditions that permits and encourages, precisely, *evaluation*, and specifically that continuous process described here in relation to both scientific and artistic activity: that is, the local figuring/working out, as well as we, heterogeneously, can, of what seems to work better rather than worse" (179). Kramer's story is sad because of the econ-

omy and health of the 44th Precinct and because the processes of evaluation, "the local figuring/working out" were cumbersome, self-serving, and harmful.

Those of us who believe in the creative possibilities of multiculturalism must, at the very least, design conditions that encourage useful evaluations in our heterogeneous world. In the midst of the plot confusions of the comedy *The Importance of Being Earnest*, written by Oscar Wilde in 1895, Canon Chasuble and Miss Prism are gossiping about the fate of Jack Worthing's imaginary younger brother, said to be dead in Paris because of a chill. "Charity, dear Miss Prism," the Canon urges, "Charity! None of us are perfect. I myself am peculiarly susceptible to draughts" (Wilde 1948, 346). Canon Chasuble is a great fool, but even great fools say true things. Morally and intellectually, not one of us is perfect. Not one of us is ever perfectly correct. All of us incorrigibly serve up disorder, impurities, and error. Charity, then, must become our thinking in general and about political correctness, multiculturalism, and cultural values in particular. Although I often lack charity at home, I remind myself of the electrifying utility of generosity of thought about others. Generosity need not degenerate into permissive slackness of judgment any more than it need degenerate into the frantic display of presents we see at Christmas in a consumer society.

Elsewhere, I have sketched a theory of cultural democracy that might frame a generous process of evaluation.

Let me repeat the elements of this theory.[8] Cultural democracy asks us, diverse and multiplicitous, to act on five principles. First, each of us—no matter what our race, class, gender, ethnicity, religion, or sexuality—deserves access to literacy, education, arts and letters, and public speech. Of course, some of us have more talent than others. I am no Louise Nevelson, the sculptor; no Rosalyn Yalow, the physicist; no Jessye Norman, the singer; no Madonna, the millionaire. Of course, some cultural works are more valuable than others. I read both Thomas Hardy and Tom Clancy, but I prefer Thomas Hardy—except, perhaps, in airports. Contingently, I will argue for the literary value of a work that, no matter what its culture of origin, shows language working itself out, refreshing and renewing itself[9]; that a number of different audiences find rewarding; that demonstrates a cross-cultural readability and translatability; that may be unwelcome but is never dull[10]; and that reminds us, finally and firmly, that good art, like talent, is a gift to us, a blessing, a bounty. Of course, too, some cultural works are more influential than others. The Bible and the Koran have had more influence than either Thomas Hardy or Thomas Clancy. Of course, our curricula must teach works of value and show why they are thought to have value, and must teach works of historical influence. Nevertheless, each of us has a human voice that deserves training.

Second, each of us must have access to our own his-

torical and cultural traditions. Our libraries, schools, and mass media must respect our individual cultural identities. I am fiercely proud of my grandfather who was born in England, arrived in New York when he was eight, and worked his way across America as a ranch hand, janitor, baggage handler. I am as fiercely proud of my grandmother who had to leave her rural school in Iowa when she was twelve and go into domestic service. I want to root my pride in these progenitors in the soil of **28** public knowledge.

Third, our pride in our own progenitors should not be an end in itself, but the home from which we travel in order to meet others. I must move from learning the story of my grandmother and grandfather to learning other families' stories, some of which will have more drama than others. My orthodoxies are not a single truth for others to swallow, but a perspective for others to use. Preferably, we will exchange our stories and perspectives in conversations, the term that William James, the great American philosopher, uses in *Pragmatism* for the process of describing a consensual view of reality. But to invoke the term "conversations" today is to risk emitting the stench of piety. A conversation is simply a working technique for making relationships and agreements happen. Imagine a circle of relationships. At one point of the circle is coerced conformity, which physical, legal, social, and cultural pressures enforce; next to it is con-

formity, which social and cultural pressures extract; next to it is consensus, moral and cognitive agreements into which people enter more or less freely and which they share wholly; next to it are coalitions, in which people with very different interests agree to act together on a specific issue or question; next to it are contests, zero-sum games that are nevertheless games, ludic encounters; next to it are rule-bound conflicts, sharp disagreements, often painful in resolution, which a set of rules govern; next to it are conflicts without rules, which raw force **29** dominates. Conversations have two functions: to help to make consensus and coalitions occur, and to help set the rules for contests and rule-bound conflicts. After a good faith conversation, history is not simply the story of my own culture, but the grand narrative of all our cultures, sometimes at peace with each other, sometimes at each other's throats. And they have been at each other's throats. Multiculturalism can be a tragic and bloody killing ground. If, however, we cross cultural borders, carrying the passport of generosity, we will see, as sharply as we see the lines on our palms, the lines of connections between us.

Fourth, cultural democracy demands cultural and academic freedom. The cultural democrat reasons that the benefits of cultural freedom are great enough to accept the price of the abuse of cultural freedom, and has the confidence to permit many diverse voices to rise up, to

float around—no matter how blasphemous, painful, corrupt, bigoted, and stupid they might be. The struggles over campus speech codes and pornography are, in part, a nearly impossible, always strenuous effort to locate the point at which pain, bigotry, and stupidity become intolerable and to whom.

Fifth and finally, no community can exist without some common values, some common moral and cultural language. Community means that some commonalities exist. The question is not whether we need commonalities but what they will be, who will create them, and how. Today, the United States has its common languages. Education has a common language of respect for learning. Among our other common languages are those of big league sports, advertising, the mass media, and a consumer economy. Not everyone knows about Dwight Macdonald, an American author; Betty MacDonald, an American humorist; Ramsay Macdonald, a British prime minister; or even Ross Macdonald, an American detective story writer. Most of us, however, know about Big Macs. Fortunately, the United States also has a common political language, when we care to speak it. This common political language has a syntax of freedom, equality, and self-government. Its canonical works are the Constitution, which has been amended in blood, and the Bill of Rights, which each of our institutions has disobeyed. This common political language does not have a syntax of a shared moral, religious, or artistic system. Paradoxi-

cally, our common political language binds us together by binding us to cultural diversity.

Being a cultural democrat can be exhausting and irritating. It is much harder than adding a book or two to a general education course; much harder than reading a Benetton ad; much harder than ordering an ethnic item from a mail order catalogue, or getting the video of *Dances With Wolves*. Doing cultural democracy demands the incessant recognition of our own moral, cognitive, and cultural inadequacies without becoming a wimp or a guilt-dripping dishrag. Drafts of error flow through all of us and all of our ancestors. As *Whose Art Is It?* so vividly shows, we are never—not ever—perfectly correct. Doing cultural democracy demands as well the incessant recognition of the moral, cognitive, and cultural lives of others. This heuristic act uses, among other tools, the prism of a broadly defined multiculturalism to see the components of history and society. Because doing cultural democracy is so hard, my advocacy of its ability to provide us with the conditions for evaluation, as well as for living, smacks of the utopian.

Because doing cultural democracy is so comparatively untested, I gaze around for rhetorical support from figures who have demonstrated their cultural vitality and power. I am aware that the rods of history chastise anyone who would proceed without hoisting, hefting, and testing their weight. I am also aware that my thoughts and actions meander on, not alone, but as a part of sev-

eral human companies. Nevertheless, I have stolen from Emerson, a canonical presence, in order to cast myself as an experimenter. My theft is this passage:

> I am not careful to justify myself. I own I am gladdened by seeing the predominance of the saccharine principle throughout vegetable nature. . . . But lest I should mislead any when I have my own head and obey my own whims, let me remind the reader that I am only an experimenter. Do not set the least value on what I do, or the least discredit on what I do not, as if I pretended to settle any thing as true or false. I unsettle all things. No facts are to me sacred; none are profane; I simply experiment, an endless seeker, with no Past at my back. (Emerson 1990, 173).

All sensible experimenters will, however, carry a copy of Jane Kramer in their backpacks as they seek the goods in our unsettling multiculturalism.

Notes

This essay began as a talk at the 1992 Modern Language Association convention in New York City. A brief version will appear in a 1994 issue of *College Literature*.

1 I have made this point before (Stimpson 1991b, 1991d, 1993).

2 Although Paul Berman, a brilliant cultural analyst, was kind

enough to include one of my articles in his anthology about PC (1992), I believe he too strongly stresses the influence of French thought in the 1960s on the PC debates and insufficiently stresses the influence of developments in the United States in the 1960s, especially civil rights movements and greater demographic diversity.

3 Some participants now prefer the term "queer studies."

4 Alice Kessler-Harris, with customary intelligence and subtlety, discusses the contradictory consequences of PC for women's studies. "I share," she writes, "what seems to be a widespread and unspoken consensus that we are eating each other alive, engaged in a cannibalism of Left feminism. I fear that we will fall victim to it unless we begin to discuss our differences openly and without fear of moral sanction" (Kessler-Harris 1992, 800).

5 Joan Wallach Scott has energetically, persuasively connected PC-bashing to the anti-intellectualism in American life (Scott 1992).

6 Michael Denning also notes a right-wing association of the politically correct with a Stalinist party line (Denning 1992, 23).

7 Newfield's article is smart and ambitious but ignores the importance of gender and sexuality as an object of PC-bashing. It also erases crucial distinctions among "conservative humanists." Victor Brombert, the thoughtful and learned literary scholar, is not commensurable with Roger Kimball, the neo-conservative polemicist. The article also underestimates the damage PC-bashing has done to public discourse and education, while finding less to admire in the university's style of governance, "managerial democracy," than I do.

8 Stimpson 1989, 1991a, and 1991c also concern my picture of cultural democracy.

9 Stimpson 1991c acknowledges my debt to Richard Poirier, *The Renewal of Literature*.

10 Although Gertrude Stein and Barbara Herrnstein Smith have
 radically different theories of what makes a masterpiece a
 masterpiece, I take the phrase from Stein. She writes, "The
 minute your memory functions while you are doing anything it
 may be very popular but actually it is dull. And that is what a
 master-piece is not, it may be unwelcome but it is never dull"
 (1971, 152).

Works Cited

34

Berman, Paul, ed. 1992. *Debating P.C.: The Controversy Over Politi-
 cal Correctness on College Campuses.* New York: Dell Publish-
 ing Co.

Cheney, Lynne V. 1992. *Telling the Truth: A Report on the State of the
 Humanities in Higher Education.* Washington, D.C.: National
 Endowment for the Humanities.

Denning, Michael. 1992. "The Academic Left and the Rise of Cul-
 tural Studies." *Radical History Review* 54 (Fall): 21–47.

Emerson, Ralph Waldo. 1990. "Circles." In *The Oxford Authors:
 Ralph Waldo Emerson,* ed. Richard Poirier, 166–75. New York:
 Oxford University Press.

Kessler-Harris, Alice. 1992. "The View from Women's Studies."
 Signs: Journal of Women in Culture and Society 17, no. 4 (Sum-
 mer): 794–805.

Newfield, Christopher. 1993. "What Was Political Correctness?
 Race, the Right, and Managerial Democracy in the Humani-
 ties." *Critical Inquiry* 19, no. 2 (Winter): 308–36.

Poirier, Richard. 1987. *The Renewal of Literature.* New York: Ran-
 dom House.

Scott, Joan Wallach. 1992. "The Campaign against Political Correct-

ness: What's Really at Stake." *Radical History Review* 54 (Fall): 59–79.

Siegal, Suzie. 1992. "Political Correctness: 'A Rhetorical Virus.'" *Tampa Tribune*, March 11.

Smith, Barbara Herrnstein. 1988. *Contingencies of Value*. Cambridge: Harvard University Press.

Stein, Gertrude. 1971. "What Are Master-Pieces and Why Are There So Few of Them." In *Gertrude Stein: Writings and Lectures 1909–1945*, ed. Patricia Meyerowitz, Baltimore: Penguin Books.

Stimpson, Catharine R. 1989. *The Necessities of Aunt Chloe*. Washington, D.C.: Federation of State Humanities Councils.

Stimpson, Catharine R. 1991a. "Meno's Boy: Hearing His Story and His Sister's." *Academe* 77, no. 6 (November–December): 25–31.

———. 1991b. "New 'Politically Correct' Metaphors Insult History and our Campuses." *Chronicle of Higher Education*, May 29, A-40.

———. 1991c. "Presidential Address." *PMLA* 106, no. 3 (May): 402–11.

———. 1991d. "Review of *Illiberal Education*, by Dinesh D'Souza. *Nation*, September 30, 378–84.

Stimpson, Catharine R. 1993. "Multiculturalism and Its Discontents." *Impart: Journal of OpenMind* 1, no. 1 (Fall): 65–76.

Wexler, Natalie. 1993. "Goes Back to 1793." *New York Times*, December 15, A-20.

Wilde, Oscar. [1948] 1973. "The Importance of Being Earnest." *The Complete Works of Oscar Wilde*. London and Glasgow: Collins.

I t could be argued that the South Bronx bronzes fit
right into the neighborhood—that whatever a couple
of people said about bad role models and negative
images and political incorrectness, there was some-
thing seemly and humane, and even, in a rueful, com-
plicated way, "correct," about casting Raymond and his
pit bull, Daleesha and her roller skates, and Corey and
his boom box and basketball in the metal of Ghiberti,
Donatello, and Rodin and putting them up on pedestals,
like patron saints of Jerome Avenue. John Ahearn, who
made the statues, says that he thought of them more as
guardians than as saints, because their job was ambigu-
ous, standing, as they did for a couple of days last year,
between the drab new station house of the city's 44th
Police Precinct and what is arguably one of its poorest,
saddest, shabbiest, most drug-infested, AIDS-infected,
violent neighborhoods. John himself is ambiguous about
"ambiguous." He says that when the city asked him to
"decorate" the precinct he thought of the Paseo de la Re-

forma, in Mexico City, with its bronze heroes—a mile of heroes. He thought that maybe it would be interesting—or at least accurate to life on a calamitous South Bronx street, a street of survivors—to commemorate a few of the people he knew who were having trouble surviving the street, even if they were trouble themselves. He wanted the police to acknowledge them, and he wanted the neighbors, seeing them cast in bronze and up on pedestals, to stop and think about who they were and about what he calls their "South Bronx attitude."

38

Raymond, Corey, and Daleesha may not have been the best of the neighborhood. Raymond Garcia, at thirty-three, is in and out of jail. Corey Mann, at twenty-four, is in and out of jobs. Daleesha, at fourteen, is a street child, in and out of junior high school. But they are a homegrown part of the neighborhood, and John, who lives in the neighborhood, too, and likes it, likes *them*—in an edgy, apprehensive way. They exasperate John, and occasionally they alarm him, the way they do the other people on the block, and, indeed, the people in their own families, but they belong to the reality of the shattered social contract we call the inner city, and John wanted them to stand in something of the same relation to the precinct policemen that they do to him and the neighbors. They may be trouble, but they are human, and they are there.

John is neither an innocent nor a fool. He is one of the best artists of his generation. He has a reputation. Right

now, there is a show of his work at the Baltimore Museum of Art, and people have seen the painted casts he makes, in the South Bronx, at the Whitney and the Tate and the Art Institute of Chicago and a dozen other important museums. Those casts, at the Brooke Alexander gallery, on Wooster Street, in SoHo, cost anywhere from twelve to forty thousand dollars. Some of John's neighbors call him "saintly," since they do not easily understand what a famous white artist—a "downtown" artist, with a fancy gallery, and museum shows, and critics at his door, **39** and a big retrospective catalogue—is doing living in a stripped-down, sixth-floor, slum apartment on one of the worst streets in New York City, hanging out with people like Raymond and Corey, and they suspect he has some sort of crazy penitential Christian purpose, like Father Hennessy, his priest at the Church of Christ the King, around the corner. John and Patrick Hennessy and a homeless street sweeper named Roberta Nazat, whose own Christian purpose is cleaning the right side of 170th Street between Walton and Jerome (and who sleeps on a couch at John's when the nights get cold), are about the only white people in the neighborhood, but John does not put himself in the same class of "saintly" as Father Hennessy or Bobbie the Sweeper. Sometimes he describes himself as "like an itinerant portrait painter," and sometimes as "like Raul,"who manufactures plaster santeros for the Bronx botanicas, but that is ingenuous. When he is talking about art, the names he invokes are

Caravaggio, who took the poor for his models "and blew art history away," and van Gogh, who took the postman and his wife and made them live forever. John has work up all over the neighborhood—there are fiberglass casts of the neighbors on four big building walls and plaster "portraits" in nearly everyone's apartment. Some people in the art world found that work sentimental, and John says that when he started making his bronzes for the 44th Precinct he was determined "to make art, make a statement," something with edge and irony and "complications." He says now that this was his mistake: he should have been thinking about making people happy. Five days after he put the bronzes up, he hired a truck and took them down, and they ended up in the yard at P.S. 1 in Long Island City, the museum where white people from Manhattan often go to look at "statements." The statues themselves look safe, even benign, at P.S. 1, but they do not look like they belong there. They are, in the jargon of public sculpture, "site specific"—though some of the policemen who saw them at the corner of Jerome Avenue and 169th Street last year prefer the word "confrontational" to describe them. No one who saw them could deny they had the "bad" South Bronx attitude. When they were up on their pedestals—at the edge of a little concrete park the city calls a "traffic triangle"— they looked less like monuments than like the Corey, Raymond, and Daleesha whom John thought everybody knew, only metal. They were part of the crowd. They

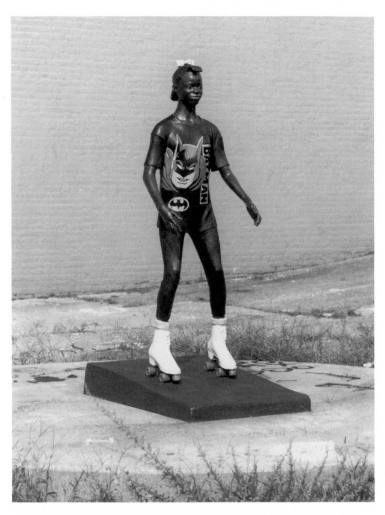

Daleesha 1992, *bronze, lifesize, by John Ahearn.*

belonged to the cocky, come-on quality of the street, to the rusty train trestle and the trashed cars and the machine shops and gaudy botanicas and rice-and-beans counters, to the dealers and hookers and welfare studs and the hip-hop children hurrying home from school with their clothes on backward, and even to the angry and respectable neighbors who complained about negative images—ghetto images—and convinced John that he should take them down.

42 Some of those neighbors wanted statues of Martin Luther King or Malcolm X, or statues of children in their graduation gowns, or of mothers carrying home the groceries, or of men in suits on their way to important jobs downtown—something to show the good side of the neighborhood to white people driving down Jerome to Yankee Stadium for a game, or taking a Bronx shortcut to their peaceful, prosperous suburban neighborhoods. A couple of policemen wanted statues of friendly policemen, helping people across the street or playing with babies. A couple of black bureaucrats talked about the pain of the neighborhood, and about people like Raymond, Corey, and Daleesha, lost to the streets, and about what happened when white artists like John Ahearn "glorified" that loss and insulted *them*. A lot of phone calls got made before the movers came, and a lot of politicians started worrying about petitions and protests and television crews and the Reverend Al Sharpton, and about John's three statues turning into a full-blown race

scandal. It made no difference that the black Mayor of New York City, David Dinkins, had borrowed a fiberglass cast of Corey with his basketball and boom box and installed it on the lawn at Gracie Mansion when he presented the keys to the city to the black filmmaker Spike Lee. Or that the people who wanted statues of men in suits instead of Corey, Raymond, and Daleesha might be mocking the pain of the neighborhood as much as they thought John had mocked it, since in the South Bronx the men in suits are generally the men who are trying desperately to leave, not the men who have to stay. It made no difference that Corey, Raymond, and Daleesha might not think of themselves as "negative stereotypes"—though Raymond often says that as far as any kind of "correctness" goes he does not have much of a reputation. Raymond was distressed for his pit bull, who had died, because he loved the dog, and the thought that it would "live in bronze" consoled him. Raymond heard that "the community" didn't like the statues—but as far as he was concerned the community was the block where he and Corey and, indeed, John lived. The community was four buildings on Walton Avenue between 171st Street and 172nd Street, and had nothing to do with anyone five blocks south and one block west, at the traffic triangle. Raymond was right, because five blocks south and one block west turned out to be as far away as Manhattan. Raymond's community liked the statues, but to the people complaining at the traffic triangle John

Ahearn was a white man, and Raymond, Corey, and Daleesha were just the statues that shamed them.

N o one knows how to settle, or even define, the argument over public art and political correctness. The art world says it's about censorship. The activists say it's about "controlling the images." The critics (depending on their politics) either quote Gilles Deleuze and say it's about "the indignity of speaking for others," or they quote Hilton Kramer and say it's about saving Western civilization. The politicians like to call it "the multicultural dialogue," but the truth is that at this particularly angry moment in New York City the multicultural dialogue is really a lot of strange and disheartening monologues. People are talking, but they are not talking to each other. It doesn't matter if they are talking about public art, or about "the white male literary canon," or about whether students at law school have to argue briefs for fathers who want custody of their children because their wives are lesbians, or about whether Cleopatra was black, or about whether Raymond with his pit bull is a proper role model for the South Bronx children. It doesn't matter if art is an accident of its "interpretive moment," as the deconstructionists say, or if art is "timeless" and addresses pure aesthetic values, as a lot of artists would say—though not John Ahearn, who says, "Hey, making somebody unhappy? That's not interesting, that's heavy!"

It doesn't matter if a statue of Raymond and his pit bull offends the guys at the Jerome Avenue pizzeria because they have no "taste" or because Raymond refused to leave the dog outside when he was ordering pizza and there was nothing they could do about it, since the dog was vicious, or because they think the neighborhood should be "represented" by a statue of a man in a suit, or, indeed, by one of them. People are suffering in the South Bronx. They live with poverty and crime and crack and unemployment, and they die young, from illness and overdose and overexposure if they are not murdered first. In the language of the debate, they are "disempowered," and to the extent that the language is correct they cannot do much about it except attack what they take to be the symbols of their powerlessness—a statue they didn't make, a textbook they didn't choose, a vocabulary of assumptions about culture that are not *their* assumptions. Sometimes the symbols focus them. More often, the symbols subvert them, and they exhaust what little energy surviving in the South Bronx has left them. As John says, "On my block, even getting yourself on welfare implies a high level of getting it together." Today, the neighbors who objected to John's statues are without a work of art for their traffic triangle, because they were more interested in the argument than in the alternatives, more interested in talking about the correctness of the statues than in replacing them. No one has written to the

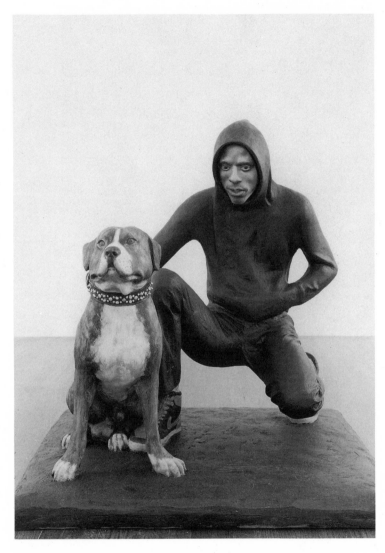

Toby and Raymond 1986, *oil on fiberglass, 47 × 43 × 39 inches,
by John Ahearn and Rigoberto Torres.*

city, or to the newspapers, saying, "We're the community, and we're going to make a new work possible." In fifteen months, no one has even asked.

This is John's neighborhood: it is part of the poorest congressional district in the country; it has the fourth-highest rate of homicide in the city; a hundred and twenty thousand people live there, and a hundred and eighteen thousand are black or Hispanic; every second person is on some sort of public assistance; one out of every three adults is unemployed; one out of every four women tests H.I.V. positive when she goes to the hospital to have a baby, and no one knows how many men would test positive if there were a way to get *them* to the hospital, any more than anyone knows how many men would test positive for crack or heroin or any of the street mixtures known as "speedballs." The facts, of course, are misleading. They do not account for thousands of illegal immigrants; they do not distinguish between black, white, and Indian "Hispanics" (who are listed as "non-white" in the census) or, for that matter, between "Hispanics" and "Latinos," who may or may not have Spanish as their first language. They do not distinguish between the Dominican dealers and the Jamaican posses who come to the Bronx for a couple of years and split with their drug money and the Puerto Rican mothers and grandmothers who appear at three in the afternoon, when school lets out, to chase those dealers off the street so the children can play. The facts are stereotypes of race and

class and culture—much more than John Ahearn's stat-
ues were stereotypes—which is why people who thought
the statues should stay worry about what it means about
"stereotypes" when poor people give something away for
nothing in return. John wants to replace the statues,
but the city might have to sell Raymond, Corey, and
Daleesha to pay for the bronze and the foundry, and it is
not certain now that John (or art or the neighbors) would
survive the process of choosing the subjects of "cor-
rect" representation under the scrutiny of his community
board, the police, the city bureaucracy, the guys at the
pizzeria, and the woman who stood at the traffic triangle
stopping traffic last fall to ask people if Corey, shirtless
and a little flabby, was the "representation" they wanted.

John Ahearn is not the first New York artist to get
caught up in arguments about representation. The
year of the South Bronx bronzes was also the year that
Jenny Marketou, a photographer with the job of decorat-
ing a Queens subway station, was accused of racism for
taking pictures of Greek Americans—she was Greek—
instead of African Americans, and the muralist Richard
Haas, who had already decorated fifteen New York City
walls, was asked to replace a panel in a series of reliefs
on the history of immigration to New York. Haas had
made the panels for the Baxter Street wall of a new city
jail, on White Street. They were up for two years, and
no one complained, but then a guard who had just been

transferred from the prison on Rikers Island saw them, and told some friends at the Department of Correction Hispanic Society that what he took to be the "Hispanic" panel did not show "positive values," and after that a lot of people did complain. They said they didn't like the sign "Bodega" on a store in the panel, and they didn't like the fact that the bodega was closed—they thought it looked like "Hispanic failure," though Haas thought it looked like "Sunday"—and they didn't like the image of a junked car or of a woman with a bare midriff or of a **49** man sleeping on the sidewalk. They thought the woman was a hooker and the man was drunk, and they were not much comforted or appeased when Haas said that the woman was based on a pretty blonde he had once seen in a book, roller-skating in Central Park, and that the man was homeless, and was there to "raise consciousness" in people walking by. Luis Cancel, the new commissioner of Cultural Affairs—and a Hispanic and an artist himself—called Haas then and told him "the process would continue." No one knew exactly *how* the process would continue, though people at Cultural Affairs talked about "the Phoenix precedent," which had to do with arguments about a piece of public art in Phoenix, and with how Phoenix settled those arguments. The "community" met, and friends of the artist's—his "advocates"— came to the meeting, and everyone testified, and then an "impartial jury" decided what the artist should do.

It was not a precedent that appealed to Haas, who

says he preferred the kind of precedent set by Solomon on another one of his jailhouse panels—the mother who loved the baby most let go. He let go. He got together with six Hispanic leaders—they met in the Gauguin Room at Cultural Affairs, which was probably not the best room for talking about stereotypes. He had offered to change "bodega" to "supermarket" or "superette" or something else agreeble to them, but the leaders said no, "supermarket" was not enough, and eventually Haas painted out the panel, at his own expense. He offered to redo the panel. He asked for pictures of "appropriate" Hispanic images to consider, but he said he would refuse to submit his changes for "community" approval. He said that political correctness was a kind of censorship, and "every bit as evil to me as the censorship of a Pat Buchanan or a Jesse Helms."

Richard Haas is a worldly man. He is not on a mission, like John Ahearn, who wants to live and work quietly in the South Bronx at least as much as he wanted his statues to stay. Haas lives in Yonkers and works in an Art Deco Chelsea loft, with Piranesis on the wall and old kilims on the floor, and eats at the Century Club, and he has sat on the Art Commission himself and thought a lot about the city, and about making the city beautiful. As far as Haas is concerned, he has nothing to apologize for, and nothing to regret, either, except the fact that the city, which considers his project incomplete, still owes him a fourteen-thousand-dollar final payment. It does

50

not sit well with Haas to be called a racist. He thinks that if the Hispanics on White Street got to choose his images of *them*, then the Jews on Baxter Street could reasonably complain about his panel on Jewish immigration, because it has to do with a Jewish sweatshop, and then the Chinese community could complain, because his Chinese panel is "all about business, and nobody's smiling." He says that to understand the tyranny of correctness you should think about what happened to Diego Rivera, whose politics "sank his art," or Frida Kahlo, whose last painting was of Stalin with a rose. He worries that good artists, like John Ahearn, are going to be frightened away from public projects by correctness, because correctness is a kind of collaboration, and really has nothing to do with art, and that in the end the public will have to live with art that is "not just wrong but dull."

There is, of course, a lot of good, new public art in the city that everybody agrees on. No one complains about the ships that Donna Dennis put on a steel school fence, down by the old Washington Market docks, and called *Dreaming of Far Away Places*, or about the terrazzo "rivers" of Africa that Houston Conwill laid on the floor of the Schomburg Center for Research in Black Culture, in Harlem. The people who fought to remove Richard Serra's *Tilted Arc* from Foley Square—it came down in 1989, after eight years of public protest—said that the arc was "ugly," "brutal," "intrusive," "hostile,"

"offensive," and "dangerous," and even that it cast a "sinister shadow," but none of them said that it was a bad role model, or was racist, or insulted minorities. When people argue about images, they are usually arguing about images of themselves.

Everybody in the art world knows the story of *How Ya Like Me Now?*—David Hammons' famous mural of a blond, blue-eyed Jesse Jackson. Hammons, who is black, installed it on a Washington street, and some black kids, thinking that a white artist was responsible, smashed it with sledgehammers. Hammons repaired it, and added their hammers to the piece, and now it is an icon. The moral of the story is that in these treacherously correct days one artist's insensitivity is easily another artist's ironic statement, and it seems to depend less on the artist himself than on what color people think he is.

John got the idea for Corey's boom box from Spike Lee. He knew that Radio Raheem, in Lee's movie *Do the Right Thing*, had a boom box, and he thought that was something "people could get into." He forgot that Lee was black and he was white—and what a difference that made as far as people getting into something were concerned. Corey never thought about it at all. Corey agreed cheerfully with everyone who liked his statue, even the people who liked it *because* it was "negative." He agreed with the woman who showed up at the triangle the day the statues came down—she was a black woman, from the neighborhood—and said, "Don't take these down,

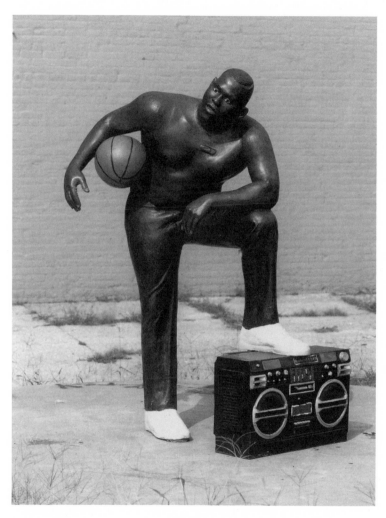

Corey 1992, *bronze, lifesize, by John Ahearn.*

you're taking *us* down. A lot of kids are dying because of these symbols. . . . We got to get ourselves together." He agreed with the old black man who said, "I admire these statues every time I pass by," and with the Hispanic guy who said, "How can this be negative? This is the Bronx!" He stood at the site and took the compliments he got, and argued with the woman who looked at the statues and said that his radio and Raymond's dog were "an affirmation of everything they"—white people—"think we are." He argued with the man who stopped in his tracks and said, "A killer dog? A basketball? A radio? Anybody can get a radio and make a lot of noise." He argued with the woman who would have preferred a statue of Aurelia Green, the South Bronx assemblywoman—because from what he knew Aurelia Green had just appropriated a baby grand piano from the local school board and moved it into her living room, and, by comparison with Green, Corey considered himself a model citizen. Corey looked at his statue on its pedestal in front of the 44th Precinct and said, "I like it. To tell you the truth, this is me, always cool. My kids are gonna tell their kids, 'That's your grandpa.' 'Cause all that hard work, look what it comes to—something to appreciate."

John Ahearn grew up in Binghamton. His father delivers the Binghamton babies and votes Republican and occasionally retreats to a Catskill lodge with his fly-fishing rod and his hunting rifle and, when he can

persuade them, John and his twin brother, Charlie, who is a filmmaker in Tribeca. Eight years ago, when John was courting a South Bronx girl—he was going to marry into the neighborhood, he says, and have South Bronx babies, and "belong" that way—he bought a ring and drove his girlfriend to the lodge to meet his parents. The engagement was over that weekend. John was thirty-three then, and settled in the neighborhood. "There was this idea, fixating in my mind, about being this mythical creature in the Bronx—like Rivera in Mexico," he says. "The idea was to become what I was going to become *here*—marrying here, becoming a real person." It was not an idea that sat well with the young filmmaker he was courting downtown. He was, by his own account, "into salvation, but I guess you could say commitment was my problem." It would be more accurate to say that too many commitments was his problem. He stepped right into his enthusiasms and made them his life. John went to Cornell, like his father, but he did not join Sigma Nu or row on the crew team or learn the Ithaca drinking songs, the way his father had. He discovered art. He shaved his head, and bought a woollen hat and an outsized thrift-shop coat and a rope to tie the coat, and moved to a commune in town, and thought he was part of a fantastic revolution—"all mixed up with masochism, Catholicism, drugs, and Vincent van Gogh." The people who counted in his life right then were his brother, Charlie, who was studying art at Colgate ("Twins hum

together in the same place" is how John puts it), and a Binghamton psychic who lived next door to his old scoutmaster at home. They met at a Boy Scout troop reunion, on Christmas break his freshman year, and before John knew it the psychic was in a trance and he and Charlie were sitting beside her, "like her angels," drawing pictures, and it had been "established" that John was going to be an artist. "I was hit by the thunderbolt of art," he says. "No one can tell me now not to believe things."

56 John started painting a picture every day. He would put on his overcoat and stand in the snow in the middle of Ithaca with his paint box and hitchhike. His "discipline" then was to stay wherever he was driven and paint whatever it was he saw—cows, trees, houses, or just more snow. He keeps three school canvases rolled up in his bedroom in the South Bronx. He has a sentimental attachment to them—to the nineteenth-century world he made of twentieth-century Ithaca, to the daubs of color he discovered in those January storms. He thought that by freezing his fingers, painting outside in northern New York State in the middle of January, he was suffering for art, the way van Gogh had suffered. He is interested in suffering—in trial and penance and confession. It is another one of his enthusiasms—"religion and art at the same time," he says. It accounts for the time he spends at early Mass at Father Hennessy's church—"the Mass with the hard core, where everybody's wired"—and for the way he refers to the priest as "Monsignor" and says

that "he's my age, but really wise, like I'm the kid and he's the adult." It does not have much to do with the Catholicism he learned from the nuns at a Binghamton day school, or from his Uncle Jack, who used to refer to John XXIII as "Satan himself walking the halls of the Vatican," but his friends think it has a lot to do with his twelve years in the South Bronx, among the poor. Some of them say that John could easily have been a priest himself.

John started making life casts in 1979, when he was twenty-seven and working in Manhattan with an artists' collective called Colab. The collective was "radical and into street art and video art"; it sent him all over the city with a Super 8 for its ongoing alternative newsreel, *All Color News.* John had pretty much stopped painting, because Colab was "anti-painting," and the closest he got to sculpture then was knocking out windows on the five-dollar-an-hour construction jobs that paid his rent. The only casts he knew anything about in those days were a collection of life casts that his friend Tom Otterness was fixing for the Museum of Natural History. John was storing the casts for Otterness, but one day he got curious and unwrapped them, and then he videotaped them, and *then* he started wondering how to make them. He discovered a book called *Makeup for Theater, Film and Television* with a chapter on making cosmeticians' masks and molds, and he called up the

artists he knew and practiced on them. He made casts of Otterness and Coleen Fitzgibbon and Robin Winters and Kiki Smith, and thought it was terrific—being a ham, having an audience, hanging your friends on the wall when they went home. His brother, Charlie, thought it was "too safe, too SoHo, too much party and not enough risk." So John went to the South Bronx—to a funky storefront "alternative art space" called Fashion Moda, which was as far from SoHo as either of them could imagine. It was twelve hundred square feet of Bronx exotica where Jenny Holzer practiced graffiti with Lady Pink, from the subway, and the Satanist Sisters, from a methadone clinic across the street, made drawings with their blood. John set up shop on the sidewalk. He cast addicts and transvestites who wandered over from the clinic. At the beginning, they were the only people he met who were crazy enough or stoned enough, or even vain enough, to volunteer. He would cast all day, and at night he would head home to Tenth Street on the IND with a piece of steaming plaster on his lap—"sometimes two, like twins, one on each knee"—and later he would hang it up at Fashion Moda and get down with the reactions. "It was like getting back to art," he says. "To paint and plaster. It was fun. It was catastrophic, I knew immediately it was great."

When John had been in the Bronx five months, a Walton Avenue kid by the name of Rigoberto Torres showed up at Fashion Moda, and asked him a lot of ques-

58

tions, and in the end asked to help him. Rigoberto was eighteen and still in high school. He worked sometimes washing dishes in a rice-and-beans shop, and sometimes making pizza downtown, and sometimes polishing rings for a Forty-seventh Street jeweller, but the job he liked was casting and painting at Uncle Raul's statuary factory, making the St. Lazaros and Venus de Milos and Elvises and Buddhas and Santa Clauses and Sitting Bulls and Nefertitis that Raul Arce supplied to the South Bronx botanicas. Rigoberto had heard about John from a couple of cousins who owned a cab; they came home one night with a story about a white guy who was out on the sidewalk on 147th Street making casts like Uncle Raul's casts, only the people were real.

Robert (his mother calls Rigoberto Robert, and that is the name he likes) went to work as John's assistant, then as his partner. He has helped John cast for the past twelve years. Most of the work that people in the South Bronx see is work that he and John cast together and John painted, but Robert makes his own casts, too, and they are very different from John's. "Robert has nothing to do with art history" is the way their dealer puts it. His painting is simple, cheerful, and direct—the critics say "literal, anecdotal, uninflected"—and has a kind of circus-poster strong-man feeling, because Robert is not interested in "ambiguous" characters. He has known ambiguous characters all his life, and he doesn't find them interesting or exotic. What Robert finds exotic, in

the South Bronx, is kindly, peaceful people. "My way of doing it is, I got to have some happiness" is how he describes the casts he paints, on his own. He says that John "opened my life, but maybe it went too fast," because John was a white man, with a downtown attraction for Bronx lost souls. "John knew something I didn't want to know anymore," Robert says, "and sometimes he left me feeling like a shadow."

John says that Robert opened *his* life. When he introduces Robert to a friend, he always says, "This is Robert, the key person." It was Robert who introduced him to the Bronx, Robert who was his Spanish voice and his Spanish credentials, Robert who took him home to Walton Avenue and made him family and after a while—"Robert has the right pacing," John says—suggested that John might like to move to Walton Avenue, too. It was the summer of 1980. John and Robert had been in a Times Square group show that was making a lot of young artists famous (Jean-Michel Basquiat and Keith Haring among them), and John had sold his first cast after the show, and got invited to shows in London and Cologne, and it convinced him that he was right about the Bronx and about the casts and about his friendship with Rigoberto Torres. He believed that with Robert he was "part of what was happening in the Bronx, part of the integrity of the neighborhood, and solidly at home." He rented the apartment where he lives now. Robert lived in the building, with

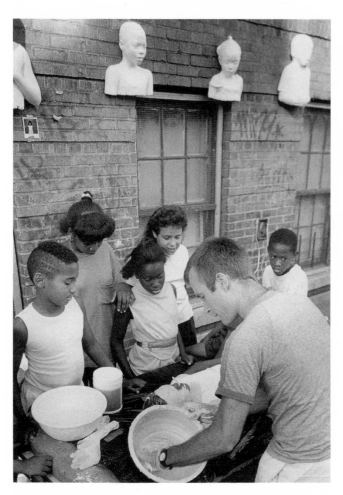

John Ahearn at work, 1988.

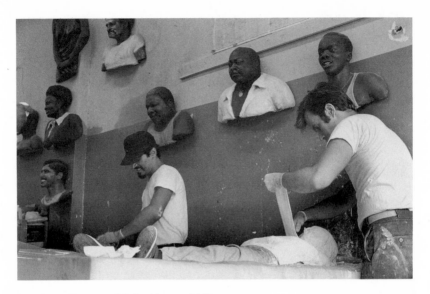

Rigoberto Torres and John Ahearn, 1983.

his parents. Raymond lived in the building across the street, and Corey lived in the building next door. John likes to say that once he knew Raymond and Corey he had three-quarters of the block covered, because the block was divided then. Corey's half of the block was black and the half where Raymond and Robert lived was Puerto Rican, and there was always some fighting— though the neighbors say that any *serious* fighting "came from outside the block," that the only block problems *they* remember were at the block party, when the black half of the block had better music, and drew the crowds, and the Puerto Ricans on the block got mad. When the neighbors talk about the summer that John moved to

Walton Avenue, they talk about "the good days." They mean that 1980 was "before the Dominicans," because Dominicans arrived on the block in the eighties, some of them dealing crack and cocaine for Colombians in Queens, and the neighbors, especially the Puerto Rican neighbors, tend to blame them for everything terrible that has happened since.

Walton Avenue is convenient. John has had other studios—he spent two years renovating an old schoolhouse on Bonner Street that was going to be his "ultimate studio," and when he finished the landlord had him evicted—but he still prefers to cast on the sidewalk, in front of two rooms he rents on the ground floor of his own building. He and Robert pass plaster through the windows. They hang their casts out, and the neighbors know they are open for business. Or they turn on the light and pull up the blinds, and announce it that way. School lets out at three in the afternoon on Walton Avenue. John says that it's his "best time." When he hears the bell at P.S. 64, on the next corner, he stops whatever he is doing and heads for the street and sits on the hood of his old white Mercury station wagon and waits to socialize. Everyone uses the street that way—like a club. People who want to find a friend, meet a girl, make a deal, keep an appointment, or simply hang out and be entertained head for the street at three and wait. If it's warm, they wait outside, and if it's cold they wait in somebody's car. John usually comes down with his dog, Summer. He

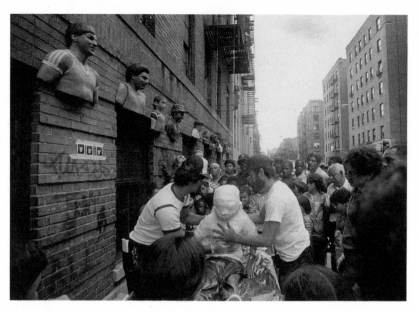

Walton Avenue Block Party, September 1985.

takes the stairway to the roof—the stairway is filthy and smells of urine—and sometimes he stops to look at his mural *Back to School* on a wall across the street from the schoolhouse, and then he crosses the roof and rings for the elevator, which is often broken but not as much as *his* elevator, on the other side of the court, and then he hits the block. He likes to keep up with the neighbors—with Risa, who lives on the third floor and is studying art at Lehman College; with Virginia, the kindergarten assistant, who moved her family a couple of blocks away, to "another worse place," and comes home to the building every day to see her mother; with Mimi, who was one

of John's first Walton Avenue kids and now, ten years later, has a daughter of her own and a husband ("but a Dominican") so devoted that he replaces her Honda every six months. Sometimes Raymond joins John. He waits, smoking cigarette butts and standing a little apart, until John is finished talking, and then *they* talk. If the conversation is long, he wanders off. He never says much to the neighborhood women. He knows that the women don't like him.

John tries to park his car in front of his building. The wagon is safe there. It is too old to interest the neighbors, whose car of choice is a brand-new Japanese sedan, a Civic or Maxima or Acura, and too battered to interest the four teenagers who are apprenticed to a gang of Dominican drug dealers, and who can usually be found together on the sidewalk, leaning against a wall and looking menacing. The boys are fourteen, maybe fifteen, and at the beginning of their training. Their job right now is picking the locks on cars and stealing the radios—and anything else they find—and they are single-minded. They were working the street the day the children at P.S. 64 had their South Bronx history lesson, and learned that Walton Avenue once belonged to a farmer named Lewis Morris, who signed the Declaration of Independence. Their interest in Walton Avenue starts and stops at Walton Avenue's cars. They do not come over to rap with John, on the hood of *his* car, and John avoids them. They are the only kids in the neighborhood he avoids.

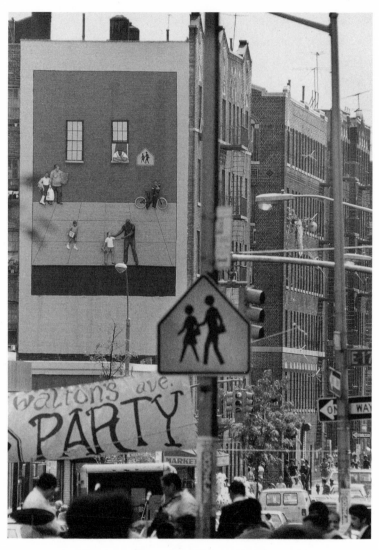

Back to School 1985, *permanent outdoor mural, Walton Avenue and 170th Street, by John Ahearn and Rigoberto Torres.*

He says that the kids on the block have a moment, before they get street smart, before they toughen, before the South Bronx claims them—a moment of "delicacy and correctness and trust that is like a flowering, and then it closes." He tries to catch that moment in his casts. "Sometimes I'll miss it," he says. "Or—it's crazy—I go away and a couple of months later it's not there. There's something aflame, and then it's gone, and the next time I see them they're like"—he leans against the wall, like one of the crack apprentices, and lifts his chin in a quick, cocky gesture that is pure South Bronx for "Fuck you!"—"and it's over."

Right now, he's trying not to miss that moment. His last show had some casts of children in pairs—he called it *Face to Face*—and kids in the neighborhood keep stopping by to check on the casts he promised them. Corey's sister, Veronica, wants her foot cast. Her friend wants a finger. Princess, who is nine, didn't like the color of her face when John first cast her. She liked the yellow of her grammar-school graduation robe, but she didn't like the "slashes" of paint on her face. They were very impressionistic, John said, "full of light, nuance, and color tone, and very flattering." Princess said "blotchy." She wanted a light face—a "one-color face"—and, for all John knew, she would have been just as testy in the hands of the artist who mixes primary colors in ice-cube trays and calls them "skin-color pieces." John had to admit that Raymond had been right when he saw "Prin-

cess" and said, "She won't like that, they don't like dark here." Princess is now a flat, light, orangy-brown—it was the color she chose—and her only complaint is that John forgot to cast her earrings. John, who says that with Princess he found he could express himself "without the yellows, the greens, and the purples," still talks about her as "the fish that got away," and he worries because Bashira, who has "eyes like wells and a deep quality to his face, like Nelson Mandela," now wants *his* graduation cast to be "one color, like Princess, and not too dark." Bashira stopped by the studio the other day and saw the cast and said, "I look like one of those African pictures." He wants to look "American." "You know, not muddy, like an old Zulu," he says. In a couple of days, he will collect his cast, and John will replace it on the wall, and the people who stop to rap at three in the afternoon will poke their heads through the studio window to see who's hanging on the wall now. There are a couple of casts John never changes: Kevin Crocker, for example, who lives in the building and helps John out in the studio. (He is, in fact, the only person besides John and Robert who has a key.) Kevin wears a high flattop, and dresses in loopy clothes, and sports a medallion with a picture of Malcolm X and a machine gun on it, but he is sweet tempered and very shy, and John says he has "perfect pitch in his character, he's never off balance." When Uncle Raul was zipping through the neighborhood in his Cadillac and knocked Kevin off his bicycle, Kevin

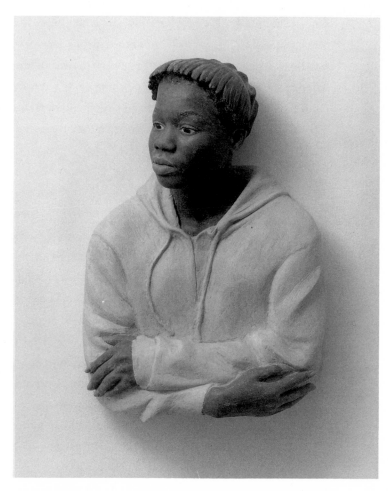

Takiya 1990, *acrylic on plaster, 25 × 18 × 7 ½ inches,*
by John Ahearn.

smiled and said, "No problem." Kevin grew up on the block, and a lot of the kids he knows are in jail now. John says that when you ask after them their mothers will tell you, "Oh, he's doing well, getting along with the guards"—as if they were in college. Their mothers are relieved to have them in jail, because on the street they could be killed. It takes a lot of "pitch" in your character to survive Walton Avenue, or a kind of genius.

It was on April 1, 1986, that the Percent for Art Program of the New York City Department of Cultural Affairs convened a panel of art experts and "concerned parties" to choose an artist for the 44th Precinct police station. Bess Myerson was the commissioner then, and the program director was a young art consultant named Jennifer MacGregor Cutting, who had been at Cultural Affairs when the program started, in 1983. In those days, most people in the arts in New York thought of the program as a gift from the city to the city—or, more specifically, a gift from a woman named Doris Freedman to the city, since it was Mrs. Freedman, at the Municipal Arts Society and the Public Art Fund, who had persuaded the mayor that public art was important, and that, given the boondoggles and the graft involved in most city projects, there was surely some money available somewhere to make New York what, in those optimistic days, was called "a museum without walls." The terms of the arrangement were that one percent of the budget for every

new public construction project in the city be set aside for an artwork, with the proviso that no single commission cost more than four hundred thousand dollars, and that the program's yearly commissions stop at a million and a half.

It sounded simple. No one in the art world then was talking about "controlling the images," and no one objected to Jennifer Cutting's panel on the 44th Precinct, which included an artist, an architect, a deputy commissioner from Cultural Affairs, a design director from the Department of General Services, which was building the police station, a captain from the precinct, and the chief curator of the Bronx Museum. The precinct architect came to the meeting. So did a couple of people from the Art Commission, the Department of City Planning, and the Mayor's Office of Construction, and four "advisers"—from the Public Art Fund, the precinct, the Borough President's office, and the office of the City Council president. They looked at slides of work by twenty-nine artists, which Cutting and her staff had culled from files on two thousand local artists. Some of the artists were white, but there were also black artists and Hispanic artists and Asian artists. No one at the meeting remembers that race was an issue. The neighborhood was an issue, and what each artist could bring to the neighborhood—and everyone was impressed by John Ahearn, who lived in the neighborhood and was well thought of in the neighborhood and did work for the

neighborhood that had clearly made the neighborhood "happy." John was one of fifteen artists the panelists voted to consider, and when they met again, two weeks later (with seventeen more artists added to the list, and four more advisers), John was the artist they chose.

It took three years for John to get his contract—which had to account for everything from site insurance to payment schedules—and a lot happened in the city in those three years. Bess Myerson was caught shoplifting. New York was about to elect its first black mayor. Multiculturalism arrived at Edward Durell Stone's lollipop marble palace on Columbus Circle, where Cultural Affairs has its offices, and Columbus himself had come to be a loaded word. The new Cultural Affairs commissioner was a black arts administrator named Mary Schmidt Campbell, who had come to the department from the Studio Museum, in Harlem. She appointed a white arts administrator named Linda Blumberg—one of the founders of P.S. 1—as her deputy for public affairs, in charge of the Percent for Art program, and in 1990, when Jennifer Cutting left, Blumberg brought in an artist and curator named Tom Finkelpearl from P.S. 1 to run Percent for Art. It was a good working office for Ahearn. Mary Campbell was enthusiastic. Linda Blumberg was enthusiastic. Tom Finkelpearl, who had worked with John on an installation at P.S. 1 (it was part of a show called *Out of the Studio: Art with Community*), was enthusiastic. No one envisioned any problems with the project. The problems

at Percent for Art in 1989 had more to do with black and Latino artists complaining about always being chosen for projects in their own neighborhoods—and not in Manhattan—than with white artists like John who wanted to work in those neighborhoods. People at the program now say that if there was any mistake in choosing John for the police station it was in not including Rigoberto Torres in the commission, or in John's not insisting that they include him.

Robert and John were having problems of their own **73** by the time John's contract arrived—problems of partnership. ("We were passing then through a real irritable phase," John says. "I said O.K., and Robert was left out, and my point of view is certainly that not having Robert for the bronzes didn't do me any good at all.") Robert was wondering who he was in the partnership, and whether he was an artist at all or just somebody "always behind John." The problem for Robert was that the people who bought art—the museums, the collectors—wanted a John Ahearn, the way the people at Percent for Art wanted a John Ahearn. They did not want a John Ahearn and Rigoberto Torres, or a John Ahearn with Rigoberto Torres. John's was the name they knew. When they looked at a piece by John and Robert, they wanted to be told that John painted it, and *then* they bought. Robert was thinking about leaving Walton Avenue, and moving to his family village in Puerto Rico and casting for a while on his own. By the time John's con-

tract was actually signed, and he started working, Robert *was* in Puerto Rico. No one knows what would have happened if Robert had stayed home: if people would have reacted differently to bronzes signed "Ahearn and Torres"; if blacks who said that they could get down with Radio Raheem but that Corey was a "fat, racist stereotype" would have been "happy"; if John would still have been the artist everybody blamed.

John didn't want to decorate the police station with a mural on a wall, which was what the precinct wanted. He says that when he heard about the project he thought, "Wow, this is a thorny gift!" He didn't really feel comfortable having anything to do with a police station, especially in a place like the South Bronx, where the line between the police and the people was so implacably drawn. He didn't think that images of the neighbors and their policemen together on a wall would do much to mend relations; he thought they would call up ironies that the neighborhood, and maybe even the police, would find hard to appreciate. He thought of the triangle—it was a dead space then, a strip of white-lined asphalt at the intersection of Jerome, Gerard, and 169th Street, in front of the station—as a no-man's-land that could become an everyman's land, where those relations would lose some of their old tension. He asked for the space early on—Jennifer Cutting spent two years negotiating with the Department of Transportation to get it, and then to get the money to construct it, and John eventually

Traffic triangle at 44th Police Precinct, Bronx, intersection of Jerome, Gerard, and 169th Streets. Site of Bronx Sculpture Park.

went to work with a landscape architect from General Services to design it. He was pleased with the architect, a young woman named Nancy Owens, who was married to an artist herself.

His first idea was to organize a huge neighborhood casting—something on the order of the castings he and Robert used to have on Walton Avenue during the summer block parties—and end up with a lot of concrete figures on the triangle. He thought of Raymond, Corey, and Daleesha, and a lot of other Walton Avenue characters, new characters. He wanted a crowd, and variety, and surprises, but the city was against concrete—the

official wisdom was that anything concrete would be de-
faced and damaged, if not destroyed—and bronze was
too expensive for a crowd. John's budget was just enough
for three or four bronze pieces, and there wasn't really
time for a neighborhood casting, or "surprises," anyway,
because once the contract was signed the city wanted
John's project designs within a few months.

It was then that John started thinking about the Paseo
de la Reforma, with its bronze heroes, and wondering

what would happen if people saw Raymond Garcia cast
in bronze and up on a pedestal—if they would see Ray-
mond in a new way, and maybe even see his pit bull,
Toby, in a new way. He thought that maybe Toby could
guard the entrance to the South Bronx the way the stone
lions on Fifth Avenue guarded the Public Library, and he
was sure his instincts were right, because everyone in the
neighborhood had liked the fiberglass cast of Raymond
and Toby he was planning to use. Corey, who had been
waiting, in fiberglass, since 1988, was going to "balance"
Raymond in the installation, and Daleesha, he thought,
would be roller-skating on a pedestal between them.

Daleesha did not exactly belong to the block, because
nobody on the block exactly claimed her. She came from
a troubled family, and lived with whatever cousin or aunt
was able to keep her, and dropped into whatever school
was convenient. Daleesha was sassy and sly, and desper-
ate for roller skates. John saw her skating down Walton

Avenue one day on a borrowed pair and thought she looked terrific ("like she was growing in front of you"), with her skinny long legs and her stuck-up chin and her funky topknot and her South Bronx attitude. He says, "It was a great image, if you treated it with respect. It was all about youth, energy, physical aggressiveness— about putting on skates and suddenly being four inches taller." He liked it so much, in fact, that he wanted to duplicate it. He wanted two girls skating together— Daleesha, who is black, and a Hispanic girl about the same age. He thought there would be a nice irony about those pieces, because it was kids like that—not college kids but street kids—that the police of the 44th Precinct were likely to meet. Both girls gave him trouble. They weren't interested in getting a plaster cast for themselves, or in seeing themselves on pedestals, or even in being famous. Art and John Ahearn didn't interest them at all. They had one thing in mind—new roller skates— and that was what John promised them if they were cast. The Hispanic girl couldn't wait; she got "negative," John says, by which he means that she never showed up for the casting. Daleesha waited, and got her skates, and then she disappeared. She never came to the installation or saw the bronze *Daleesha* up on its pedestal. John thought for a while that she had died.

Raymond Garcia had just come home from a prison boat in New York Harbor, and he did not want any more attention from policemen than he already had. He wanted to see his dog "immortalized in a nice river place, with trees"—somewhere peaceful and clean and, especially, "not the Bronx." He said, "When you do a lot of injustice, people don't forget you." And he was right. The local cops see him now and call out, "Yo, Mr. Statue! Mr. Statue, you haven't paid us a visit lately!"

One of his cousins has a court order forbidding him to enter her house. Even Robert, who used to worry about Raymond, says, "I'm out of here," whenever Raymond sits down. But not John. John believes in Raymond. He's drawn to "weirdos and crazies and prickly, unpredictable characters like Raymond"—characters who move him and scare him at the same time. He refused to give up on Raymond when Raymond freaked out and called the police and announced that he had dumped John in the Hudson River, and even when Raymond set him up and Raymond's friends came over and robbed the apartment, and he is not about to give up on Raymond now, when Raymond is sick and alone and often has nowhere to sleep but an abandoned apartment building around the corner. The building is dangerous. Raymond says that more people get killed in a week in abandoned buildings in the Bronx than in some American cities (though he claims there is a kind of "tranquillity" about *his* building, because the cops are too frightened to come in and clear

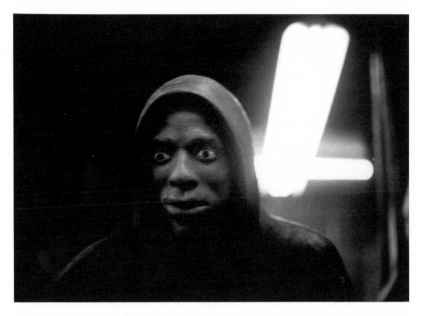

Raymond *at the Cavalier Renaissance foundry.*

it). Raymond sleeps there in a sleeping bag on the floor, and he eats "in my coat by candlelight"—which is his way of saying that there is no heat and no electricity—and whenever he feels like company he visits a "college guy" who moved into a room upstairs with a pile of books, and who impresses Raymond by sweeping every day. John worries when Raymond stays in the building—he worries that someone will steal his sleeping bag and Raymond will freeze—but Raymond has made it clear to the addicts and dealers and derelicts on the floor that "I'll kick down your door and take what's mine if you come near me."

The truth is that Raymond has a new pit bull to protect him. The dog belongs to his cousin June Bug Garcia, who lives on the block and occasionally leaves him food, but it's Raymond who walks the dog, and Raymond who loves it, and Raymond who named it Sakura, which he says is "Morning Blossom Flower" in Japanese. Raymond says that Sakura is "just as smart, just as tender" as Toby, and he doesn't seem to notice the mothers, at their windows, yelling to their children to cross the street when he is on the block walking Sakura, or the fathers running out to snatch the children away. Right now the block looks wonderful to Raymond, and he doesn't want to lose it. He talks about the block parties, "with John and Robert doing art, and there ain't no complaints, there ain't nobody saying, 'Hey, you're standing on my shoulder!' Put folks in the welfare line, it's black against Hispanic. Not *here*. This community, it's peaceful and quiet." He tries to supply the block with useful news— news that the price of bulletproof vests is rising, or that one of the local politicians is "more evil than a pit bull," or that the Taft High School, two blocks east, where one new neighbor wants to send her daughter, is known by its graduates as Training Animals for Tomorrow, or that the crack dealer across the street "died a horrible death, from grease around the heart," or that the super in John's building has been charging five dollars to turn the elevator on.

Raymond is close to being the local vet. He got his

training stitching Toby after pit fights. He says that he put Toby in the pit because "this is the Bronx, and if your dog can't defend himself, how's he going to defend *you?*" and that after a while he and Toby had "the Bronx reputation," and people were paying him to pick their dogs and stitch them, too. Toby had arrived on the block in a bowling bag of stolen Texas pit bulls. He was the puppy that tried to bite Raymond when he put his hand in the bag. Raymond said to himself, "That's the one I want. He's the smallest, the youngest, he got no time to sleep, he got to fight his way to the bowl." Toby, in his day, won some serious fights, and "took some serious ass kicking." Then he lost his longest fight, and after five and a half hours of sewing up the holes Raymond decided it was time for Toby to "retire." "His fighting days were over, and I was running crazy in the streets, and I didn't want to drag him down," Raymond says now. He tried giving Toby to a boy in the neighborhood— Toby liked children. But grownups "upset" him, and he wouldn't let the boy's parents out of their bedroom, and Raymond had to take him back. "The father was happy to see me" is how he describes it. Three years ago, Toby "passed away from chicken bones in the kidney," and Raymond thinks it was just as well, because three years ago Raymond was usually in jail.

He was convicted first for knifing someone in a fight, and then for possession of cocaine, and once he was held on suspicion of murder, and by the time his dog died he

81

could tell you all about life on Rikers Island, and how it compared to life on the prison boat or at the federal prison "camp" near the Canadian border. His opinion of prison is that "the people will do anything to keep you from leaving." He likes to talk about the Colombian dealer who kept a razor blade in his rectum, and about the Jamaican dealer with thirty razor blades hidden in his dreads, and about the dealer who was so dangerous that the agents who came to move him had to chain him

by the legs and shoulders and handcuff him to weight-lifting belts from the prison gym. He stands on the street, or sits in a Chinese-Cuban place on the corner of 170th and Walton, where John (who leaves a big tip whenever Raymond is with him) sometimes takes him for a meal, and where the corner hawker peddles wilted roses, and tells his gruesome stories. He says that "for sure" his life would have been different if he hadn't lost his one job, which was cleaning schools. He recites those schools like a litany. Sometimes he says, "Help me!" He is intelligent, and sensitive, and he knows he might have made something of his life. Cleaning schools was the closest to having a future that he ever came. "It was my mom or my job," he says, because his mother was sick then. There was no one else to collect his brother Edwin at school, so Raymond "took ten minutes" and that was the end of his career. "Since my mother was sick, I got a record *this* long," he likes to say, stretching out his arms. "I wanted to hurt people, hurt myself. It's hard to describe

if you haven't gone through it. It's not like a book. A book can tell you a story, and you can feel it—feel the pain. But a book can tell that story twelve ways, and reality's different. Reality's like a statue. It goes in one direction."

There is AIDS in Raymond's family. Edwin died young —he was retarded—and then a lot of other people in the family died. Raymond has a brother in California "who engages in illegal activities, like me." The only brother left on Walton Avenue is dying now. His name is Freddy, and everybody on the block likes him. John likes Freddy—Freddy gives him haircuts—and Raymond worships Freddy. He says, "Freddy took away all my violence. Freddy's everything I'm not. I wake up just glad I survived, but Freddy wakes up and says, 'Hi, how you doing?' He's glad to be alive. Freddy's gentle and has twenty suits, and all *I* got is the clothes on my back and my conscience. When Freddy dies, I die."

The cops on Walton Avenue never shout, "Yo, Mr. Statue!" to Corey Mann. They don't recognize Corey on the street, because Corey, on the street, is (as John puts it) "pretty fresh." Corey is given to handmade bomber jackets, and sharp new suits with "Corey" emblazoned on the back, and a lot of gold and diamonds, and the Corey the cops know from the traffic triangle didn't have a fancy jacket, or a shirt that said "Just Add Bacardi to Lemonade," or a set of rings that spelled out

"Corey" in diamonds across the knuckles of his right hand. The Corey they know had a boom box, not a black Buick Regal with Camaro chrome from "a guy in a truck," and, as for the basketball, when the cops at the site said, "Look at this guy, he's got no shirt on, and he's not even playing," Robert asked them, "How do you play basketball in a three-piece suit?" and Raymond said, "Maybe Corey's checking out the team, for the next game." Corey has a low opinion of policemen.

He says, "They're all nasty, you understand me? And some of the white ones are outrageous. But the ones I say hello to, they white. The ones that's black, like me, or Puerto Rican, they got to prove something. They got attitude. They got a gun, a badge. They say, 'You low-life nigger, get a life!' But I say, 'We all bleed, we all got face and fingers, we all gonna die. You got too much attitude. Tomorrow's not promised just to *you*.'"

Corey has attitude himself. He is under the protection of an enormous gold Madonna, which he wears on a gold chain—he says she is not a Madonna at all but "Santa Barbara, who was a caring person, a sweet person, like she show no hostility"—and he is going to reward her one day soon by putting diamonds on her halo and rubies on her baby's halo. Nobody really knows where Corey gets his money. He joined the hospital workers' union this year, and he says he has a job in the pathology lab at Mount Sinai, but this fall the only job he had was answering the telephone at Call a Date and "telling the

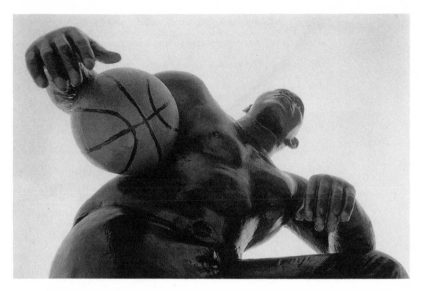

Corey, *Bronx Sculpture Park, 1991.*

women what they want to hear." It wasn't a bad business. Five minutes on the phone with Corey at Call a Date cost fifty dollars, and Corey got nine of them. His only complaint was that he couldn't talk like a woman, too— which some of the men there could—because those men could pick up any call, and they got paid more. "The job was, I got to keep you on the phone" is how Corey describes the work. He says that, being a Scorpio, he had a natural talent for it, and he may be right, since, at twenty-four, he has had several devoted girlfriends, four children, and "a little thing" with a woman of forty. John worries sometimes about the children being "ghetto bas- tards"—he says that Corey's arrangements remind him

of the song about ghetto bastards by Naughty by Nature, which John considers the "No. 1 rap group"—but Corey thinks of himself as a family man, "only with more families than most." What makes him a family man, in his opinion, is that he lives at home, on Walton Avenue, and sees to it that nobody like Corey Mann comes near his sisters. Corey has always considered himself a guardian of the block, and of "virtue" on the block, and, as far as he is concerned, the only reason the people on Jerome

Avenue didn't acknowledge him as *their* guardian is that they never had the pleasure of getting to know him. "George Washington, two lions—if they don't know you they won't like you, right or wrong?"

When John and Robert are casting one of the block kids and want a hand—someone to make the carrot juice or someone to tell tall stories and make the kids laugh, so they don't get nervous—they leave word up and down the block and hope Corey will appear. John says that Corey was "very instrumental" with Daleesha. Corey describes it this way: "She's very fussy, you understand? She wants a banana. You buy the banana. She doesn't eat it." John has a rule about casting children: Never alone. ("You got to touch a little girl, you don't want a 'he say, she say' later," Corey says.) He tries to get a parent or an older brother or sister to be there, but he couldn't find any of Daleesha's relatives, so Corey "stood in." He stood in with his cousin Kenyatta—a nine-year-old with a mop of dreadlocks—when John cast Kenyatta, and he

says, "I'm glad I was there, 'cause one time the plaster stick to the little hairs on his leg, and there's a little pinch, it psychs him up. He goes 'Aaagh!,' like we was hitting him with hot irons—like we was *killing* him. And I'm thinking, 'If the family hear that scream . . .' You understand me?"

Corey considers himself a kind of art expert, because John and Robert have cast him five times. John likes his hair, which is short, with laser stripes shaved into it in dapper patterns, and he likes the big space between Corey's front teeth, and the fact that Corey keeps his favorite cast on his living-room wall, above the mantelpiece and right next to the "art" photograph of a rose and Corey's face reflected in a glass of champagne. Corey has been living on Walton Avenue since he was five years old and his grandmother brought him north from South Carolina to meet his father, who was just back from Vietnam. His father never really recovered from the war; his mother was sick with lupus, which left her gaunt and bald and her skin in the patches you see on John's cast *Veronica and Her Mother*. The *Times* once used it to illustrate a story about the poor.

Corey claims he was always happiest in South Carolina, which was "straight country, all hogs and cows," but he managed to cover New York. He went to school on the block, and finished at Samuel Gompers High School, and found odd jobs for himself—there was a parking lot in Harlem, and a McDonald's in the Village, and a con-

struction crew at the top of Central Park, and a "jeans boutique" in the South Bronx—and that's why it hurt him, he says, when the bronzes came down. "The cops, they wanted to know 'What are these derelicts, these three black hoodlums, doing here?' and there was this old black man wanted to know 'Who're them? They ain't nobody special.' It hurt me.'Cause the rough guys—they dead or in jail, and that's not Corey. Everybody here watch me grow up. They know I'm a kindhearted person.

I always admired John, you understand? He's lived here for so long, and we all love him and enjoy him, but you know what I'm saying, he's a very caring, understanding person, and a lot of people kind of try to take advantage. Like John's working on a cast, and he messes up a little old T-shirt, and they say thirty dollars to replace it. I don't take with that. I don't let nobody disrespect him. I don't let the kids say, 'Hey, Beanhead,' like they do with some people on the block. This is *my* block. I say, 'If you want to be down with the crowd, stick that needle in your arm—go three blocks down. If you're selling here, me and a couple of guys, we'll have a little talk with you. If you mess with John Ahearn and his art, I'll personally have a little talk with you.'"

John spent 1990 making the rounds with a maquette of Raymond, Corey, and Daleesha. He showed it to review boards at the Department of Cultural Affairs, the Department of General Services, the Police Depart-

ment, the City Council, the Office of Management and Budget, the Mayor's office, and a couple of other places, whose names he forgets. He went to the Art Commission for approval—the people there were interested mainly in the paint he was planning to use on the bronzes, which they said were "very forceful"—and, finally, to an open meeting of Bronx Community Board Four, where everyone wanted to meet "the artist with the walls" and the only complaint came from a policeman who thought that a bronze policeman would have been nicer. John went home from the meeting with "community" approval— though it is probably accurate to say that a community board of thirty-five people appointed by their borough president is no more and no less "the community" than a block on Walton Avenue is the community. The local district manager is an old white pol from the old white Bronx named Herbert Samuels. He says now that when he saw John's maquette, he thought, "Oh God, are we in trouble!" But that wasn't what he or anybody else told John. All the people on Community Board Four are blacks and Hispanics, and what *they* said was "Hey, so you're the guy from Walton Avenue we've been hearing about." They did not often get to meet an artist, or to talk about art. They did not even get to talk about "the gypsy-moth problem," or "the tree-pruning problem," the way people on community boards in places like Staten Island do. The agenda at meetings in the South Bronx is usually drugs and homicides, and John's visit was a distrac-

tion—something in the way of a social call. John gave their meeting a touch of celebrity.

The first real complaints came much later. They started at the Department of General Services, in September last year, less than a week before the bronzes were scheduled to be installed. They did not come from the man who had sat on the 44th Precinct panel at Cultural Affairs, or from the man who had worked with Nancy Owens on the traffic triangle, or from the man who had visited Cavalier Renaissance, in Bridgeport, the foundry where the bronzes were cast. They were not, officially, "official." They came from Arthur Symes, a black architect who had just been hired as the assistant commissioner in charge of design and construction management, and from Claudette LaMelle, a black therapist with a degree in social work, who was the executive assistant to the D.G.S. commissioner. Neither of them knew much about the South Bronx—Claudette LaMelle lived in the North Bronx, and Arthur Symes lived in Manhattan, in Battery Park City—and neither of them had actually seen the bronzes. They had seen some project drawings lying on an office desk—Arthur Symes says that a white project director had called him over and said, "Take a look at this!"—and then some Polaroids of the drawings, and then some Polaroids of the pieces themselves, and they had concluded that "this was not a happy family, this was negative elements." Claudette LaMelle says, "Raymond was definitely not a boy with

Lassie." Her view of Raymond was that if Raymond had a picnic on the block not many parents were going to send their children. Her view of Corey, whom she calls "the fat guy"—she says she showed the pictures of Corey to some kids at a day-care center and they said, "too fat to be a basketball player"—was that "he's hanging out" and not doing anything useful, for the neighborhood or for himself. Her view of Daleesha was that she was "more like death walking." She didn't like the spiked collar on the dog or the hood on Raymond's sweatshirt, because the city is full of crack dealers in hooded sweatshirts, and she didn't like the fact that the bronzes were "all black, no color, no hair ribbons, no pink, no blue—nothing."

If she had gone to the foundry, she would have seen that Daleesha had white skates and yellow socks, and a big yellow bow in her hair, and red-and-yellow pictures all over her Batman T-shirt, and that Corey had white sneakers and an orange basketball, and that Raymond's dog was brown and white and Raymond's famous sweatshirt was really a deep blue—that the color emerged, layer by layer, in John Ahearn's remarkable brushwork. She was not much interested in John's brushwork, and neither was Arthur Symes. She thought the work was "racist and subjective," and Arthur Symes thought it was "naïve" and said that no serious person in the community, no really sensitive person, would have "put those negative elements on a pedestal."

No one seems to remember who made the first phone call. (As far as the people complaining at D.G.S. were concerned, the 44th Precinct traffic triangle was "a done deal" and they weren't responsible, and it was certainly not a question of censorship.) What Claudette LaMelle remembers is that "the feeling of inappropriateness here" was brought to the attention of the people on Colum-bus Circle—and this was certainly true, because Linda Blumberg remembers a call to her commissioner "about

a work we commissioned that was going up within a week and that was 'outrageously racist,'" and Tom Finkelpearl remembers Linda coming into his office that morning and the two of them sitting there, bewildered and distressed, and talking about what to do. They talked all morning. They talked about how much a part of his community John was, and about trying to "explain" John to the people at D.G.S.—they were sure that if they did those people would understand that the last thing you could say about John Ahearn was that his work was racist. They talked about what would happen if the South Bronx bronzes became a scandal, and about protecting John, and about protecting art from politics. They talked about what would happen if people all over the city started removing the city's statues.

Mary Schmidt Campbell had just left Cultural Affairs for the Tisch School of the Arts, at New York University, and a woman named Charmaine Jefferson was standing

in as commissioner until the mayor named someone to replace her. Linda Blumberg went to Mrs. Jefferson with the story—she wanted her to know that John was an artist of integrity, the best artist she could imagine for the project—and then she and Tom went downtown to General Services. They were not prepared for anything like the anger they encountered when they took out their slides and said, "Let's show you this in context." Linda Blumberg had wanted to make a "presentation." She thought that their slides from the South Bronx would help Arthur Symes and Claudette LaMelle "get to know John and his work in the community," but Arthur Symes and Claudette LaMelle were affronted and upset, and they were clearly not interested in a slide show. They wanted the people from Cultural Affairs to accept that the South Bronx bronzes *were* racist—that they didn't represent the struggle of the community or have anything to do with the way that struggle should be represented, that Corey was an outrage, "out of shape and out of work," and Raymond was a drug dealer, and Daleesha was a "zombie." They didn't understand why the people from Cultural Affairs kept talking about "creative freedom" and "artistic freedom." They said later, "Does that mean freedom to do whatever?" And the people from Cultural Affairs didn't understand why *they* were talking about John Ahearn as "a white artist in a Third World community." They knew that John was a member of that community, but Arthur

Symes and Claudette LaMelle seemed to be saying what Arthur Symes still believes, a year later: "He's not of the community because he's not black—it's simply that."

Arthur Symes says that when he saw John's project drawings "my first thought was, 'This guy's not a black artist.'" He compares John trying to "represent" the South Bronx to himself trying to design a building for Chinatown that would say to the people, "That's Chinese!" He doesn't think it's possible, and Claudette LaMelle doesn't think it's possible. Claudette LaMelle says that if John were really part of the community "he would have befriended Raymond much differently"—by which she means he would have spent his time straightening Raymond out instead of wrapping him in plaster. She doesn't credit what Raymond says—that John, wrapping him in plaster, did more to straighten him out than anyone else, anyone *from* the community, ever had.

The meeting was a standoff, though Linda Blumberg says that Arthur Symes, especially, moved her with his arguments. Symes had talked about losing people to drugs and the streets—"He saw John's pieces as monuments to everything he'd been trying to save his own community from"—and Linda knew his sadness was genuine. She left his office "filled with contradictory feelings," and she and Tom went back to *their* office wondering what they should have known or thought or done, wondering what had gone wrong with the "process." They had thought that the process was as fair as it could get:

they gave three-quarters of their commissions to minori-
ties; they spread those commissions around to cover all
the boroughs and all sorts of neighborhoods. Tom himself
had gone out of his way to compensate for the fact that
"for every white middle-class artist in SoHo who sends
in slides there's a black or Hispanic artist somewhere in
Brooklyn or the Bronx who has never heard of us." There
were outreach programs at Percent for Art. Linda says
that they had done their best to see that the process—
of selection, of approval—was clean and at the same
time that the commissions were diverse, aesthetically
and even politically. She knew that any physical site in
New York City was also a political site, and involved a
lot of people taking political power seriously.

John installed his bronzes the next day. He had heard
about the meeting. Linda Blumberg had told him
there were "problems," but everyone at Percent for
Art supported John, and as far as he was concerned Gen-
eral Services wasn't "the community." He wasn't worried
about the community. And he wasn't worried about the
site. He was excited about the site. "I wouldn't say the
basketball player or the girl are my best pieces," he says.
"It was the site that counted." After five years, he wanted
to see his statues installed. He wanted to walk across
Jerome Avenue from the El and into the community and
see Raymond, Corey, and Daleesha standing there like
guardians, and he was sorry the cops at the 44th Precinct

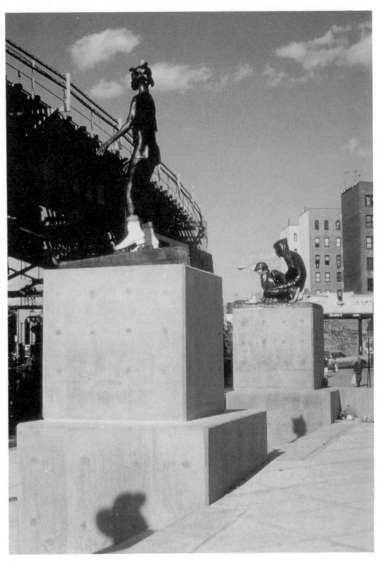

Daleesha *and* Toby and Raymond, *Bronx Sculpture Park.*

wouldn't be there to see them, too. Their new thirteen-million-dollar station had been such a boondoggle, with so many labor and construction problems, that no one had been able to move in.

John says now that what happened that day—it was September 25, 1991—was a kind of "spontaneous protest," and that he knew right away that it was happening. He hadn't wanted an official occasion—just the pleasure of people walking by and stopping and maybe saying, "Wow, finally, this is really *us!*"—but he says that when the crane was lifting the bronzes from the truck "the mood wasn't right and I had real unease." Corey was at the installation, with his mother, and John was glad she got to see it, because she was terribly sick by then; by the next morning she had died. John's girlfriend, Daisy Maxey, was there—she had driven in from Long Island for the installation—and so were Tom Otterness and Nancy Owens, and Charlie, who was making a video, and a couple of other downtown people. But mainly it was "the community" that came, or, more accurately, it was whoever happened to be out on Jerome Avenue that Wednesday morning and was curious enough to stop and watch.

A woman named Alcina Salgado was out watching. Her apartment, on Gerard Avenue, overlooked the triangle, and she took a proprietary interest in the site. She had been complaining about it ever since the police station was a vacant lot, with a Montefiore methadone clinic

operating out of an empty synagogue at one end, and an accumulation of weeds, and garbage piled up everywhere. Mrs. Salgado likes to describe herself as "the lady who cleans up the neighborhood," and she knew exactly how many weeds and how much garbage, because she was the person who went out one day in 1978 and collected it, and put it in blue plastic garbage sacks, and saw to it that the city came and took it away. She didn't want the police station. She complained about the station going up, and then she complained about parking places around the station. She wanted "the decent people" to reclaim the neighborhood, the way decent people had reclaimed her building, after she organized the tenants in 1983, and collected money and hired a lawyer and took their powerful slum landlord to court. They ended up with fresh paint, an intercom, a lock on the front door, an elevator that worked, new windows and mailboxes, a new roof, a new super, *and* a rebate for a year without services. "I'm a neighborhood stalker" is the way Mrs. Salgado puts it. "If I see a hydrant broken, or a streetlight out, I pick up the phone."

She is not on Community Board Four, but she goes to meetings—though not to the meeting John went to— and the people on the board know her, because when Mrs. Salgado picks up the phone it is usually to call them. She called the board about John's statues. She didn't know John, or that John had made the neighborhood walls, or that she and John had a Walton Avenue connec-

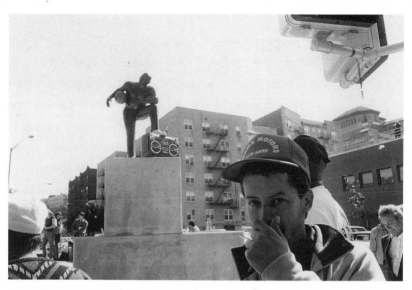

Bronx Sculpture Park.

tion, because Roy Cohn grew up on Walton, back when
it was a Jewish street, and Mrs. Salgado had worked as
"head housekeeper" for the family of G. David Shine, the
famous Private Shine who helped Cohn put together the
"evidence" for Senator Joseph McCarthy. But she knew
she didn't like the statues. "There are people who go to
school and people who go to work, and then there are
the people we find on the roof," she says, and she had no
doubt that the statues she saw at the traffic triangle that
day were statues of the "roof people." It was bad enough
to have them on the roof, smoking crack, hanging out,
making trouble, and to have to confront them; Mrs. Sal-
gado didn't want to look out of her window every morning

and see them in front of the station, too, on pedestals. She wanted the police to protect her from people like that. She seemed to think that if John Ahearn was angry at the police and wanted to confront *them*, he should have put his own statue on one of those pedestals. She stood at the corner that day—a prim black woman in steel-rimmed glasses, a woman of propriety and grit who had answered an ad forty years ago in Minas Gerais, and come to America and worked hard and sent four children to college—and she stopped the traffic. She cornered people on the street and showed them the bronzes, and asked them, "Isn't this awful? Who is responsible?" She was asking them that when John went home to his apartment to pace—he was trying to figure out what to say to people like Alcina Salgado, and he still wasn't sure—and she was there asking them when he came back to the triangle, two or three hours later.

John walked up to her and said, "I'm John Ahearn, I'm the artist. I want to talk." All he knew was that he wanted to get this small, formidable woman away from the site, to someplace calm, someplace neutral. He took Mrs. Salgado to Walton Avenue. He showed her his *Back to School* mural on the wall, gave her his catalogue called *South Bronx Hall of Fame*, asked her what *she* wanted. "She wanted college kids," he says. "She told me, 'I worked all my life to raise my kids in the right way,' and I could get into that. She thought the bronzes were evil, ugly images. She loved me, but she said, 'These things

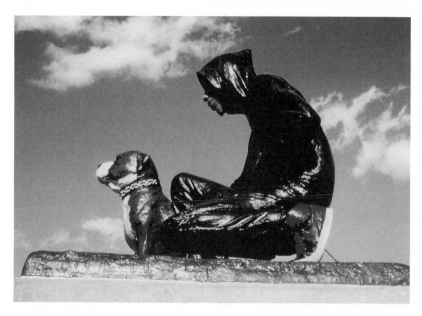

Toby and Raymond.

are going to go.' After two hours' conversation, those were her parting words!"

That night, John started thinking about Raymond. He decided that Raymond looked "like Halloween." In the morning, he got up and went back to the triangle with a can of epoxy paint and thought some more and then he repainted Raymond's face. He gave Raymond a "sweet expression." He wanted to make Mrs. Salgado happy. He knew why Raymond scared her. He says he could get into that—more, anyway, than he could get into the "art people" who looked at Raymond and said that he was "like a Hopper, staring into the middle distance." He

wanted Mrs. Salgado to see "the other Raymond" in the Raymond who, as likely as not, had robbed his apartment two times, the Raymond who always hung around high, making John and everyone else on the block nervous. He believed there was something Raymond knew—some secret, some truth—that he himself might never experience but that a statue he painted "right" might capture and even communicate to a woman who was afraid. He wanted Mrs. Salgado to see that Raymond was "beautiful *and* heavy."

When John talks about that day now, he uses the word "subjective." He says, "It's so subjective," because there was really no battle at the traffic triangle, no terrible confrontation. Not many people complained. And the ones who did complain were angry (or offended or amused), but they weren't a hostile crowd. Nobody was demonstrating. Nobody was screaming. John says it was "the art world against the community," and when he does he sounds as if he weren't part of the argument at all— just someone caught in the crossfire of other people's priorities, someone choosing sides, a victim of his own art. He talks about making people in the South Bronx "happy." He does not easily admit that he needs to make them happy, or why he needs to make them happy, but anyone who really looks at the work he does in the South Bronx knows that his community—the people he loves and casts—is a wellspring for him, the source of a re-

markable vision. He needs the Bronx because his art is important. He says, "It's so subjective. To the art world, my bronzes were serious, ironic. They had oomph, they were strong. They were an 'artist's' pieces, and they looked good at the site, but I thought that day, 'They'll never look like this again.' I knew that soon they'd look terrible. Bad. Uglier than Mrs. Salgado said. So I said, 'Fuck 'em, the art world!' It's not my job to be fighting these conservative progressive people—people like Mrs. Salgado. I respect these people. It's not my job to be the punk artist in the neighborhood—like, there's a lot going on in my artistic life besides this installation. There's my concept of casts in people's homes—the execution may be shoddy, but to me those casts are more valuable than a bronze, or a better piece in a collector's home, and if I've misread my people it means I've misread myself and my concept. There's my murals. I'm well aware of why art history hates saccharine, sweet things, but my murals are more important than the bronzes. They're popular, in a simple, storybook way, and that's good, that's a stronger statement, that's maybe *more* serious, because it's more collaborative—it draws on the deeper, idealistic life of the people. What I felt was, I had a choice. I didn't want trouble. I knew the news people would be down. Imagine—all these nice ladies crying on television! I thought, 'I'm not going to win this.' Either I was going to be on Mrs. Salgado's side or I was

going to be her enemy. I refused that. I went to sleep that night, and the next morning I woke up and called Linda. I said, 'We'd better take these bronzes down.'"

John says that after that it was mainly "damage control, with everybody doing what they could to throw a big wet blanket over the whole thing." Linda Blumberg had told him not to be hasty. She wanted to reassure him that the program supported the bronzes, and supported him, whatever he decided. She said, "In my experience, the artist knows what works and what doesn't. It should be his decision." John went back to the site with Charlie, who videotaped the reactions: the woman who thought the pit bull was going to "pounce on me"; the policemen who drove by taking snapshots and said, "I don't believe this! You gotta be kidding!"; the man who said, "This is what people are going to see on their way to Yankee Stadium?"; and Corey, who said it was "just like the Bronx, no respect for art." Tom Finkelpearl hung out at the triangle for a day and did a "vox pop." He talked to the people who stopped, and discovered that half of them weren't interested in the bronzes at all but that a lot of the ones who *were* interested thought the South Bronx bronzes were "a slap in the community's face." Tom told John that he would defend with his job John's right to keep those bronzes up, but John said, "It's in my best interests to remove them."

John was less worried then about his bronzes than about what to say to Raymond and Corey. He was going

to have to tell his friends that their images had been "rejected" by the community. "It was a rough thing," he says. "I knew it could be negative." He talked to Corey first, after his mother's funeral. It was at the Mormon Chapel, near Lincoln Center—she had had a death-bed conversion—and John says the scene at the temple, "with all those black mourners in the pews and all those grim white elders staring at them from the pulpit," was "like a metaphor" for all the misreadings of the past few days. Corey was grieving, too distracted to take in much of what John told him. But Raymond took it hard. Toby had been the most important thing in Raymond's life—and maybe the only living creature that had loved Raymond without equivocation—and Raymond had always taken his statue to be *about* Toby. When John said that it was coming down, Raymond wanted to organize all the pit-bull owners in the neighborhood and protest. "I felt bad," John says. "I'm close to Raymond. He's one of my favorite people, and I didn't like that I was doing this to him. I tended to put it that they—the establishment—wanted him down." What the establishment really wanted was to avoid a scandal.

John went down to General Services. He wanted to explain to Arthur Symes and Claudette LaMelle that "I don't handle things confrontationally." Ninety percent of his fee was already paid, and he was going to refuse the rest—he wanted to tell them that. He wanted to talk about what to do with the bronzes, and how to replace

them, and he wanted to ease Linda Blumberg's mind (she and Tom were with him) by assuring the people at General Services that the decision was his, that he was not going to call up ABC or the *Times* and complain about censorship, that the story of the South Bronx bronzes was not going to explode. It was not a very friendly meeting—John mentioned that he had a "relationship" with Raymond, and Claudette LaMelle told him it must have been a "sour relationship"—but when Arthur Symes said that John had given the city "some good stuff, but it's the wrong stuff," John tended to agree. He paid for the movers. He kept his statues safe until the movers came. He didn't want the neighbors throwing paint all over the statues—which is what some people said would happen. He called up Mrs. Salgado to explain. He didn't blame anybody. He wasn't angry. The only time he got angry—it was the day the bronzes came down—was when a black police officer drove over from the old 44th Precinct house, on Sedgwick Avenue, and had himself filmed giving a speech about how horrible the bronzes were and telling the movers what to do, pretending, in fact, that the movers were there because of him. "It was some jerk shoring up political points," John says. "He knew when he came that the bronzes were going. They were going because of me."

That day, at the traffic triangle, John had a conversation with Mrs. Salgado's daughter. It was not, John says, "the kind of conversation I'm used to in the neighbor-

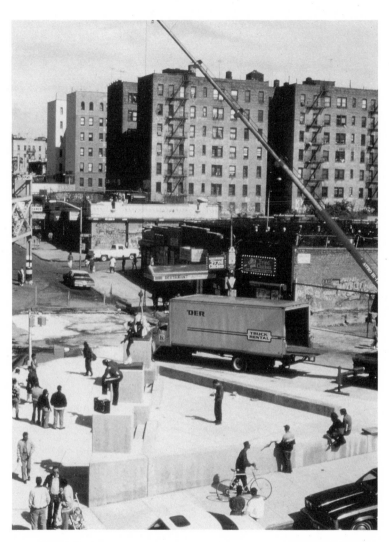

Removal of sculptures from the site.

hood." It was more of a downtown conversation, because Angela Salgado was in many ways more of a downtown person. She had studied at Sarah Lawrence, and she belonged to the film editors' union and had worked on a Martin Scorsese movie and a Woody Allen movie, sponsored by a black "affirmative action" group called Harlem, Fight Back that was better known for disrupting sets and overturning catering tables than for getting its members hired. Angela was angry and articulate. When

John met her and heard her talk, he said, "You scare me, you should be a politician or a professor," and she said, "No, I'm going to be an artist. Artists have much more power." Angela was not in the best mood to see John's bronzes. She had just been turned down for a SoHo apartment that was "available" when her best friend—a white friend, from Sutton Place—asked. "I was so saddened and disgusted," she says. "I got home and saw those three hideous statues and I said to my mother, 'I can't live in this neighborhood if those statues stay.' "

She took on everybody at the site. When Nancy Owens tried to explain what she had wanted from the space, and talked about triangles, and alluded to Egyptian forms, Angela said, "Look at what cross-purposes we're at. You're talking about Egypt, and I'm talking about a shiftless fat slob with a boom box, a junkie with a dog, a mountain of stereotypes." When John tried to explain what he had wanted from the statues, and talked about a "challenge to the police" to deal humanely with the

neighborhood, she said the statues were "an affirmation of the police's distortions." She said that the neighborhood needed to get along with the police, not to confront them with images that scared them. She said, later, "If not the police, then who's going to get the people who rob me or rape me?" She said that the women of the neighborhood, negotiating their way between the violence and the police, might have been "an image that means something"—that she saw herself as "that little girl, wedged between those two vicious guys" on pedestals. She said that those guys were "the difference between a working-class neighborhood and a ghetto," that they were "totems of racism." She said that John had *chosen* the South Bronx, that John had choices—which was "the one thing that most of the people here don't have." She thought that race was the issue. She thought that John was "condescending and offensive," because he had come to the site with paint and lightened Raymond's face to make him "palatable."

109

She liked John's work. She said later that she thought the work was powerful—that John had "opened a dialogue that was very inspiring"—but she also thought that John was "passive aggressive," and she said, "I don't let him off." Her arguments were sophisticated. Not many people in the neighborhood use terms like "passive aggressive" to describe John Ahearn, or even know what "passive aggressive" means. John says that she "knew all about me." She knew how fashionable his gallery was,

and what a John Ahearn went for, and she was prepared
to use that information in the neighborhood if the bronzes
stayed. She knew that Nancy Owens' husband was the
sculptor Rudolph Serra, and that Rudolph was Richard
Serra's brother, and that white people who didn't like
Richard Serras *Tilted Arc* had been able, finally, to get
it removed. She follows the art scene in the paper. She
read recently that Nancy herself and her Tribeca neigh-
bors were protesting against a drug-treatment center on
their street, and now she wants to know why Nancy
Owens's family is "too precious to live with a center that
will transform those people," while her own family is not
too precious to have to live with those people at their
most dangerous. She says that white people who think
of the First Amendment mainly as a way to "protect the
freedom of expression of artists from SoHo" should ask
themselves, "What makes Nancy Owens's a legitimate
protest and Angela Salgado's protest 'censorship'?"

John talks a lot lately about the "dignity" of the com-
munity. He says that if his neighbors were invited
to Lincoln Center they'd find a way to rent tuxe-
dos and "put their best image forward"—"they wouldn't
want Lincoln Center to be a showcase of their private
problems, or of how bad the reality is *here*, or how much
fighting there is in the neighborhood." He wants his
downtown friends to understand that a statue, especially
a statue other people see, is "another way of trying to

look your best." He is working hard to please his neigh-
bors. He says that for him the value of "making art" in
the South Bronx is less the art than the "getting close to
people"—or, anyway, close enough so they are ready to
spend half an hour wrapped in hardening plaster, breath-
ing through straws in their nose—and seeing art make
them happy. His famous Bronx walls—the Kelly Street
schoolgirls jumping rope, the families on Fox Street and
the families on Dawson Street, and his own Walton Ave-
nue neighbors—made everybody happy. The walls were
"positive," he says, though at the time he made them
he worried about their not being "art," and wondered
if maybe they were a little folkloric. Now he says that
thinking about his trouble with the South Bronx bronzes
has convinced him that the "discipline of 'happy' is just
as important as the discipline of 'strong' or 'tough,'" and
maybe even harder to accomplish—that the casts he
makes to please a neighbor are "purer than something
with too much of myself in it, something individual." His
friends in the art world think that the trouble unhinged
him. They worry that he is "sacrificing himself as an
artist," because from where they stand—in SoHo and
Tribeca—his bronzes were a breakthrough, some of the
best work he ever did, while the walls he likes so much
were a "capitulation." They know his casts for the Fox
Street wall—the wall he called *We Are Family*—had fine
painting. Strange grays; browns lit in impastos of blue
and green. They were a composition *in* color, not a com-

"Banana Kelly" Double Dutch *1981–82, cast fiberglass, oil and cable, by John Ahearn and Rigoberto Torres. Kelly Street at Intervale Avenue, Bronx.*

position about color—that was what made them family. But it is not clear that John would make the same wall now, or that "the community" would let him, either.

Some of John's friends want him to come home, by which they mean home to a couple of square miles of lofts and galleries in lower Manhattan. They assume, as artists often do, that the perfect therapy for a troubled artist is the company of other artists, and coffeehouse shoptalk, and a lot of dropping in at the galleries to make him feel "connected." They have many theories about

what John Ahearn is doing in the South Bronx. They have a Christian theory—a "Blessed are the poor for theirs is the kingdom of God" sort of explanation. They have a guilt theory, because John had a brother—an older brother—who died at college, inhaling Freon from a balloon, and they say that John feels guilty about surviving and is in the Bronx punishing himself. They have a twin theory, because John is close to Charlie, and they think that once Charlie was married and settled and had his own family John went "looking for his twin"—in Robert, and in the lost young men in the neighborhood. They say, sometimes, that even his casts are twins, because every time John casts a neighbor he is giving that neighbor a mirror of himself. John has heard all the theories— including the "revisionist" theory, which holds that when John makes a moving and compassionate statue of a girl who happens to be a whore embracing her grandmother who happens to be a drug dealer he is "revising" the block to fit his own sentimental notions of what the block should be—but John says it is really just a question of home. "This is my preferred life, better than my old life," he tells the friends who drive up to Walton Avenue to see him. "Let's not forget, I have a clear need to be here." Sometimes he says he is "performing a service, living on Walton Avenue," because, with John Ahearn on Walton Avenue, the art world gets its Bronx vicariously, and never has to leave Manhattan. He thinks that the people who said, early on, that he was doing a lot for the South

Bronx should have been saying that he was doing a lot for the art world, giving rich white people a bridge to the life there, and to a different kind of vitality.

The market in art is terrible these days. John is lucky to sell one plaster bust a year, let alone any of his free-standing casts, which have to be reconstructed in polyadam or fiberglass, and twelve thousand dollars is not enough to keep John and Robert, whom he supports, in paint and plaster. Last year, they started travelling. A couple of weeks before the bronzes were installed, a twelve-year Ahearn-Torres retrospective opened at the Contemporary Arts Museum in Houston. It went from Houston to Rotterdam and Cincinnati and Honolulu, and John and Robert went with it, doing a month of site castings in those three cities, and hoping to make some money. This summer, they went to Washington for more casting, and another show. The work was exhausting, and the trips were disappointing, because no one who wanted a cast had any money to spend. Brooke Alexander says it might not have mattered if there *had* been money: even in good times, John has a real ambivalence about making money from his art. He has always given away his work in the neighborhood, or left it on loan in museums that liked it, and he is very disciplined about "sharing." Whenever he makes a cast for himself, he duplicates the face and gives it to his model—which accounts for the fact that there are John Ahearns hanging

all over the South Bronx, next to the plaster saints from Uncle Raul and the anniversary photographs.

Brooke and John have their own arrangement. Brooke says, "I had to get used to John standing apart." He means that the gallery gets its Ahearns when John Ahearn is ready to part with them, which isn't often, since John puts most of his work in a storage warehouse on Jerome Avenue, a couple of blocks from his apartment, while he figures out where it "belongs." It's not that he thinks every cast belongs in a living room on the block, but he does think every cast is part of an "engagement." He says that it has to do with trust—with seeing a kid he knows carry a piece of sculpture home and hang it, and with the life of that piece in the kid's life, with watching the kid grow up, and repairing the piece for him when he breaks it, and getting to know his family, so the family will bring its saints from Uncle Raul's factory over to the studio when *they* get broken. It has to do with art in the life of the block. Brooke calls it "John's agenda," and he goes along with it, because John has always been clear that his commercial life is something very separate from his life as an "itinerant portrait painter" on Walton Avenue. Brooke says that John agonizes when those two lives come together at the gallery. He tells a story about John's first show—it was in 1983, when the gallery was still on Fifty-seventh Street, and John was so reluctant to have his South Bronx pieces at

a Fifty-seventh Street gallery that he insisted on showing in July, when most people who buy their art on Fifty-seventh Street are at the beach. (He said later, "How come no one bought?") Brooke says that when John and Robert have a show John worries much less about the collectors and the critics than about the neighborhood: Does he invite the neighborhood? What will the neighborhood eat? Will the neighborhood like the food? What will the neighborhood think when it sees the Alexanders' beautiful Wooster Street loft, with its fine paintings and its sleek furniture? Brooke thinks that John's "understanding" with the neighborhood used to be healthier. It was cut-and-dried—something on the order of "I do your portrait for you, and then I get to do what I want on the piece I keep." Over the years, it has got complicated. It is complicated now.

It may be that John wanted Walton Avenue on his own terms. He wanted art to ennoble the street, and all the people to be as beautiful and good as a few of the people were, and with the bronzes reality got in his way. He tried to protect the neighborhood from the bronzes he had made for it, but he never consulted the people on the street or called up any of the influential black and Hispanic people he knew—people like Bill Aguado, who runs the Bronx Council on the Arts and understood what John was trying to say with the bronzes—to defend him. He didn't want arguments in the neighborhood, or confusion in the neighborhood, or the media coming

in the neighborhood and asking poor people what they thought about a famous white artist spending a hundred-thousand-dollar city commission on "negative images." ("John made an ethical choice *against* something, not *for* something," one of his friends says. "I think he's uncomfortable with the real ambitions lurking inside him.") The neighborhood is, if nothing else, realistic about money, having seen so little of it. The people there who love John, the people who call him "saintly," might easily have understood that, after spending five thousand dollars on molds, and sixty thousand at a foundry, John Ahearn was not really getting rich on them. John doubts it. He says that the neighborhood simply hasn't made the connection between money and art.

Critics have written a lot about the civilizing influence of John's pieces—about how much the neighborhood "respects" and "reveres" the pieces, since, remarkably, they are rarely vandalized or defaced, and are never stolen. John thinks those critics are fatuous. He is certain that if any of the people who robbed him over the past twelve years thought they could take a piece of plaster sculpture to a fence for a couple of dollars, the way they took his radio and his television, and even his batteries, there wouldn't be a John Ahearn left on Walton Avenue. "The bottom line is that a St. Christopher medal worth four dollars is gone as fast as a battery around here," he says. "Look around. Have you counted the VCRs? Where's the appliances? This place is empty,

there's nothing that's for sale, and the cynical bottom line is that life's tough, and people steal, and I'm lucky that they haven't made a material connection between their poverty and my work." He says that if the neighbors had started thinking about a hundred thousand dollars they might well have asked why no one built them a basketball court with the money, instead of a Corey with a bronze basketball tucked under his arm—and not even in the game. Maybe. The people who hated *Corey* think that

John should have consulted the "community," but maybe the people who liked *Corey*, and wanted it to stay, also think that John should have consulted the community.

It all depends on what "the community" means. Bill Aguado says that in the South Bronx the community too often means the people who see a chance to get involved and win. The community is politics, and has a very narrow focus that doesn't usually have much to do with culture—which is why he thinks that "if we lose John, who's committed to the community, to the culture of the community, we lose more than three statues." Aguado was sorry to see the bronzes go, and he doesn't credit any of the arguments about "stereotypes." He says that most arguments about racist stereotypes are racist arguments—that in the end the people who talk about protecting the community by "controlling the images" the community sees are much more patronizing and paternalistic than the John Ahearns who make the

images. Aguado's mother comes from Puerto Rico, and he has argued with Hispanic friends who thought that John's statues were a "slur on the community." As far as he is concerned, they were "an accurate portrayal" of the community. "Art is who we are—it's exactly who we are," he likes to say. "Corey and Raymond are 'life,' whether you like them or not, and if we can't look at life, at what's *real* life, how can we get beyond it? What are our alternatives? Some safe abstract thing? Garibaldi on a horse? Everybody 'happy'?"

Aguado often talks about a public sculpture that was commissioned for another Bronx police station, on Eastchester Road; it was an abstract piece, a square grid of blue metal sticks, and most of the cops hated it, but one cop thought it was terrific, and even "correct," because it would stop a car if "terrorists" attacked. Aguado says the grid was "safe art"—even correct art—but he thinks it would be more important to have Raymond, Corey, and Daleesha in front of a police station than a lot of blue sticks, because people would look at them and start talking, even arguing, about reality, and maybe learn that Raymond and Corey were never the problem, that the conditions that produce a Raymond and a Corey are the problem. He thinks that when the trouble at the traffic triangle started, the "dialogue" should have started. In Japan, you give a piece of public sculpture two hundred years to settle and *then* decide if it's appropriate. In

Phoenix now, the rule is five years. In the South Bronx, people settle their differences, and their scores, faster. They have to.

"I had this idea, Love thine enemy," John says. "I was going to replace the bronzes. I was going to donate my time, and work with Robert, and I had some ideas: 'service workers' with kids, a fireman Robert was casting, maybe a garbage collector and a policeman. Last December, I called Mrs. Salgado for advice. I thought, 'Embrace the enemy. Make Mrs. Salgado the first figure of my new group for the precinct.' But when I asked her she started complaining. I thought, 'Wait a minute. After all we've been through—and you *know* me—you're still complaining. How can I please you? I can never please you. Maybe you're always complaining.' This is the first time I'm saying anything bad about her—right? But when I hung up the phone I felt, like, liberated. Like, I love her, but not as much as the first time."

Last year, Rigoberto Torres moved. He says he had heard it all. The sad stories. The bravado. The South Bronx attitude. He knew that Raymond, whatever he had to say about loving dogs, was "number-one difficult," and that Corey, whatever *he* said about straightening out the block with "little talks," got no respect on the block—that the quiet, decent people raising children on the block were not impressed by Raymond's grief or Corey's chrome. He had been on the block too long,

he says, and even in the building too long. His parents were still in the building, and one of his sisters, and the woman he had lived with for eight years, and their children, and, of course, John. The block had been Robert's world since he was eleven years old.

On the block, families like Robert's are an Old Guard —"the guys from the past," Robert calls them. Now the people moving in are Mexicans and Dominicans and Ecuadorians. Robert says that the block looks great to them. "They come from almost nothing, they come to *this*, they want too much too fast and lose control." But he does not really understand why the block, the neighborhood, "the community," still looks good to someone like John. "John's got this thing," he says. "He likes Raymond, he likes Corey. His best art comes out of that. But I've been through it, I don't want to see it anymore. The neighborhood's tough—it was tough when I grew up—and whether you mess up or not, it's inside your head. My father prefers work, my brother prefers a beer, everybody's different. But you got to hang on to reality tight here, never let the bad happen. You see a friend turning bad. You see it happening in front of your face, and you use the friend as a mirror. You say, 'I don't want to be this person.'" Now there are too many people on the block that Robert doesn't want to be. He wants to be himself. He loves "the work of making art." He talks about the "amazing materials"—the plaster, the burlap, the Jeltrate and the K-Y jelly and the Johnson & Johnson

fast-setting bandages, and even the wires and screws—the way John talks about the "deep wells" of Bashira's eyes. He says that when he met John he knew immediately that John was doing exactly what Uncle Raul was doing, that John's casts were going to be the images that meant something, the images that people wanted to live with, and even needed to live. He talks a lot now about having a factory of his own, full of people "working together, making art." "I'm used to the Bronx—I know how the Bronx behaves—but right here I don't know who I am. I've been working behind John so long I didn't even see what other people"—the people who didn't like the bronzes—"saw. I only saw how *we* felt about art, and people. Maybe John thinks I should have seen, should have warned him. I heard, at the site, '*We* don't look like that!' and 'Who's this drug dealer?' and 'Who's this fat guy, blasting sound real loud?' But all I saw was Raymond and Corey, and I thought, 'The neighborhood knows these guys. The neighborhood knows that a drug dealer can be anyone—a sixty-year-old lady, a fourteen-year-old girl.'"

When Robert moved, he didn't give anyone his address—just "the Bronx." He dropped out of circulation. He bought himself a portable phone. When John wants Robert now, he calls and makes an appointment, or he waits for Robert to appear at the studio, which Robert does nearly every day. All John knows about Robert's "other life" is that he lives with a woman, and that they

have a baby, and all Robert says about that life is that they belong to *him*. He means not to the block, not to the neighborhood, and not to John. Robert has disappeared before. He spent two years, all told, in Puerto Rico. He moved from village to village, casting the people he met, and he made a beautiful statue of the singer Ruth Fernandez. "It's not how long you go for," he likes to say. "It's the not telling people where you are, or when you're coming back." Robert wanted to prove that he could make it alone, without John, without the block, without the Brooke Alexander gallery. And since then he has always felt "a little strange" on Walton Avenue—as if Walton Avenue weren't his block anymore, as if their studio were "John's place." John still pays for the studio, and every month he pays Robert for his help. It is not an arrangement that Robert likes. When the income-tax people ask, "What exactly do you do?" and Robert says he's an artist, they tell him, "Robert, you *cannot* be an artist. Where are your sales? Where are your receipts?"

Robert does not think "white" and "black," "downtown" and "uptown," "Anglo" and "Hispanic." He had never heard of political correctness or role models or positive images before the bronzes. He had never even considered the possibility that Uncle Raul, who wanted to cash in on Columbus's birthday, might be stuck with a couple of dozen huge gilt Columbuses at the end of the year, because no one was buying Christopher Columbus anymore. As far as Robert was concerned, the only "in-

correctness" John practiced was his smudgy color. He told John, from the start, "People don't want too many colors on their face. Maybe later, but right now they don't know nothing about art, and we're teaching them. And we learn about the community from that. Like, what's black, what's brown? What does it mean?" He thought then that the only real mistake he and John had made was rushing around the world casting, trying to show people that "everywhere you go, everyone is suffering"—trying to buy the time to "work on a Raymond for a few months and produce a lot of beautiful things for the Bronx."

Robert thinks now that maybe John romanticized the Bronx, that he never looked at the people he met on the street as clearly and coolly and skeptically as he looked at the art-world people downtown. He agrees with John's friend Daisy that John embraces everybody he meets in the Bronx "for two months" and then says, "Help! What am I going to do? Get me out of this!" When John talks about the "apprentice" they found in a rice-and-beans shop around the corner—about how poetic he was and how he blew John's mind, talking about "what Tintoretto lost when he moved past Titian," and how "disappointed" in the apprentice John was when he got mad and nearly killed Raymond—Robert will say, "He was interesting, but he had problems, he needed a green card," or, "He was interesting, but we didn't know his family." When John talks about the apprentice who lived in a field behind Uncle Raul's factory, and how gifted *he* was—how

he could model a figure in action in two days—Robert will remind him that the kid was "nuts," and so violent he nearly killed them all. When John talks about *Robert*, about how Robert is "not intellectual or art historical but has the gut impulse and expression of a true modernist," Robert will say, simply, "I've been there, I've kicked around." When John talks about his own fantasy of the Bronx—about *belonging* to the Bronx—Robert says, "It's time to go. I don't want to live and die here, in this one spot."

John wears a dark-blue sweatshirt with a hood, like Raymond's sweatshirt, and the same sneakers. But he does not look like a drug dealer in his sweatshirt and sneakers. He looks like a healthy, good-looking, blue-eyed downtown artist—which, of course, is what he is. Raymond, in *his* sweatshirt, always reminded John of the hooded monks El Greco painted. He liked the image so much that he cast Raymond in his hood and lent him to a gallery in an old convent near Huelva, and everybody who saw him was moved by his "spiritual" quality. Raymond in Huelva was "site specific," the way Raymond on Jerome Avenue was site specific. Only, the sites were different. Jerome Avenue was a police station, and a statue in front of a police station does not evoke the same associations, or ironies, as a statue in a convent.

This fall, there was an essay on John in *Artforum*. It was about "stereotypes"—about whether John was guilty

of stereotypes, and about why a statue of Raymond was a stereotype if Wesley Snipes as a crack lord in *New Jack City* was not a stereotype. It was not the sort of essay that the city calls "press." But it raised the only important question. What is "wrong" with reality? John's pieces are all "real" people. Those people are not models for other characters, the way Caravaggio's neighbors were models for Mary Magdalene or St. Paul. They carry their own history and their own names. One of the few times that John

gave anybody another name was when he cast an addict who was thrown from a roof in a crack fight. He cast him with a cross around his neck, and his arms in casts, and his hospital gown pulled down, away from his broken skin, and called him Lazaro. St. Lazaro is a sufferer, and people in the South Bronx believe that he suffers for them. Some of those people—people on Walton Avenue—think that John should have put Lazaro in front of the police station, not because it is "Lazaro" but because it is beautiful, "something to appreciate." They know all about the "real" Lazaro. They know he is not a saint—the same way people on Fox Street know that Smokey, the man on the wall called *We Are Family*, is not a saint but a fast-living, philandering local preacher. They would rather have Smokey on the wall than one of their local politicians—they call their politicians "poverty pimps." When they look at Smokey, they don't say, "John Ahearn is right in the tradition of George Segal and Duane Hanson," the way downtown people do. They say, if they are

Hispanic, that John is right in the santero tradition—in *their* tradition.

Last week, John delivered a cast of Raymond with his brother Freddy to Brooke Alexander, where it is lit well and hangs on a clean white wall. It is a delicate cast. Raymond is above Freddy, cradling his brother in his arms, and Freddy is reaching up to embrace Raymond. The brothers are smiling, and Raymond's eyes are shut tight. It could be said that Raymond looks "happy." People who come to the gallery keep returning to the cast. It draws them, and often they do not know what to say. Sometimes they talk about the painting, which has nothing to do with the flat tones and surfaces the neighbors on Walton Avenue like; the painting on *Raymond and Freddy* is expressionistic and almost violently tender, and it seems to explode from the skeletons underneath the skin. One man said, "It's like being in a church in Palermo." Another man said, "It's Gothic—it's like being in a fifteenth-century German church." It looked to one woman like a Deposition; she was moved, and she said, "It's Paul receiving Christ." The cast was about art history, and it was also about faith, and love, and dying, and Raymond and Freddy, and it doesn't really matter if you call that "the Italian tradition" or "the German Gothic tradition" or "the santero tradition." John and Robert are the only South Bronx artists working in that tradition now. It would be nice if some black artists were working in it, too (and maybe, unlike John, a black art-

ist would have fought to keep his bronzes), but it would be no more "appropriate"—not if you happen to believe that an artist can't accept somebody else's tradition and make it his own, make it something new, make it truly "multicultural."

John likes to play a Naughty by Nature tape about the ghetto. "If you ain't ever been to the ghetto, don't ever come to the ghetto, 'cause you wouldn't understand the ghetto, so stay the fuck outta the ghetto" is how it goes. The rap reminds him of black people he used to meet in the sixties, who didn't want white freedom riders coming South, demanding to help them, and he says, "I understand what they're saying." It was one of the things he thought about when he decided that "to stand and fight for the bronzes would be the wrong thing." He still wants to replace the bronzes. He says he owes it to himself and to the neighborhood (and to Mrs. Salgado, who called the community board last month to say that the traffic triangle was filthy and there was graffiti all over the empty pedestals). "I still have this fantasy of who I am," he says. "At nineteen, I got a taste of something— my identity as an artist—and it's still there. I have a handle on it. It's so important to me to keep that flame alive." Tom Finkelpearl, at Percent for Art, wants John to finish the project; he is trying to finance it. Luis Cancel, at Cultural Affairs, seems to want him to finish the project; he is very politic, and talks about "the natural tension between the vision of the artist and the vision of

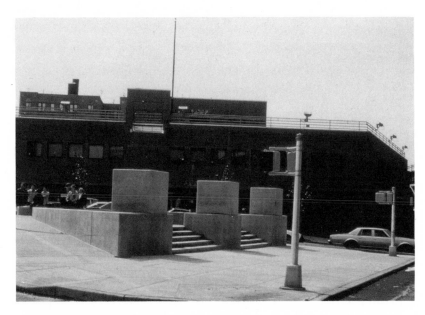

Empty pedestals in front of 44th Precinct, Bronx.

the patron," and about "the pool of people with whom the artist will have a discourse." The people at General Services do not want him to finish it; Arthur Symes says, "To be candid, I don't think that artist should attempt to do anything else on that site," and Claudette LaMelle says, "It's like a bad marriage where you say, 'Let's try again,' but it won't work."

The critic Michael Warner, who is gay, white, and often "correct," wrote recently that a democratic culture had to involve judgments "that do not entirely stem from the self-representations of the people af-

fected." He said that people—black people or Hispanic people, or, for that matter, gay people—can represent themselves in ways that are just as damaging as the ways other people represent them, and that, maybe because of this, "the difference between oppression and freedom can never be reduced to the difference between speaking for others and speaking for oneself." The fact is that any society in which no one has the right to speak for others, or represent others—in a congress, in a piece of sculpture, in a poem—is not just a reduction but a reductio ad absurdum. The categories of representation become monstrously small. "Black" becomes "black man" and "black woman," and then "poor black man" and "poor black woman," and then "poor black man or woman from the block"—and then you have no society left, no community, no "culture." The people who disapproved of *Raymond* assumed that the real Raymond was black, whereas Raymond was in fact Puerto Rican, and the Puerto Ricans in the neighborhood liked his statue. Claudette LaMelle said, "To advocate for you, I have to ask myself, 'Have I walked in your shoes?'" She may have thought that, being black, she had walked in Raymond's shoes, but she hadn't—unless you accept the fact that, from the point of view of art or empathy or compassion, a black woman can walk in a Puerto Rican's shoes, or in a Puerto Rican junkie's shoes, or in the shoes of a Puerto Rican junkie with AIDS, or in the shoes

of any man. It interested Linda Blumberg that nobody at their meeting had talked about "Americans," or even "New Yorkers." Claudette LaMelle and Arthur Symes called black Americans "African Americans," which is currently correct, and Hispanic Americans "Latinos," which is also currently correct, but Claudette LaMelle referred to the Asian Americans in New York as "Orientals," which is not correct at all—it was not a matter of prejudice, it was a matter of yesterday's vocabulary.

Jennifer Cutting remarked, after the installation, that if the bronzes had gone up right away—in 1986—there wouldn't have been a problem. She meant that in 1986 the categories were broader. John Ahearn may have been thoughtless or insensitive or, in his word, "dumb" to put Raymond on a four-foot pedestal. He may not have thought enough about what pedestals mean in a neighborhood like the South Bronx, or what bronze means. He may not have understood that a "monument" to Raymond in the South Bronx, where there are no monuments to Alcina Salgado, or, indeed, to Martin Luther King, means something very different from a monument to an Aztec king on the Paseo de la Reforma. He may not have realized that in the absence of more "heroic" images in the neighborhood some people were going to object to the implication that Raymond was the only available image of themselves. He may have overestimated their irony (or their art history), or underestimated their shame. But he

was not "wrong" to represent Raymond, or to think he had the right to try. His brother says, "It's all he's stood for, all his work has stood for. He's lost in the Bronx until those pedestals are filled."

Photo Credits

D. James Dee, courtesy Brooke Alexander, New York. Pp. 41,
53, 69

Ivan Dalla Tana, courtesy Brooke Alexander, New York. Pp.
46, 61, 64, 66, 112

Jeanette Montgomery, courtesy Brooke Alexander, New York.
P. 62

Nancy Owens, courtesy New York City Department of Cultural
Affairs. Pp. 107, 129

Tom Finkelpearl, courtesy New York City Department of Cul-
tural Affairs. Pp. 75, 79, 96, 101

Ari Marcopoulos, courtesy Brooke Alexander, New York. Pp.
85, 99

Jane Kramer's books include *Europeans*, *Unsettling Europe*, and *The Last Cowboy*, which won The National Book Award in 1981. She has been a writer for the *New Yorker* since 1964 and divides her time between New York City and Paris.

Catharine R. Stimpson is Dean of the Graduate School at Rutgers University. Her most recent book is *Where the Meanings Are: Feminism and Cultural Spaces*.

Library of Congress Cataloging-in-Publication Data
Kramer, Jane.
Whose art is it? / Jane Kramer : introduction by Catharine R. Stimpson.
p. cm. — (Public planet)
ISBN 0-8223-1535-1 (alk. paper). — ISBN 0-8223-1549-1 (pbk.)
1. Ahearn, John, 1951- —Criticism and interpretation.
2. Public sculpture—New York (N.Y.) 3. Afro-Americans in art.
4. Hispanic Americans in art. 5. New York (N.Y.)—Ethnic relations.
6. Bronx (New York, N.Y.)—Ethnic relations. I. Title.
II. Series.
NB237.A35K73 1994
730'.92–dc20 94-11528 CIP